HISTORIC
HANOVER

HISTORIC
HANOVER

Tales of a Quaint New England Town

COMPILED BY THE HANOVER HISTORICAL SOCIETY
AND JOHN J. GALLUZZO

THE
History
PRESS

Published by The History Press
Charleston, SC
www.historypress.com

Copyright © 2018 by the Hanover Historical Society
All rights reserved

First published 2018

Manufactured in the United States

ISBN 9781467138826

Library of Congress Control Number: 2018932093

CONTENTS

CONTENTS

FOREWORD

Barbara Barker came late to Hanover. Any old Hanover family will tell you that. She got here in the 1960s, when the baby boom was in full motion and the need for teachers—everywhere—was one of the country's most pressing needs. But, as the old saying goes, there's none more zealous than a turncoat. When Barbara got here, everything about Hanover fascinated her, from the old house she moved into and the stories on the stones in the cemetery to the flowers that bloomed year after year in the places they and their predecessors had highlighted for decades, even centuries. Barbara fell in love with Hanover and shared that love with her young students at the Sylvester School and then with the residents at large through her history articles in the *Hanover Mariner*.

She never stopped questioning the past, which is the strength of a true historian. If she couldn't find the answer in a book, on the pages of a newspaper or in a dusty old town report, she asked someone who would know: her centenarian friends Anne and Lucy Bonney, the descendant of a prominent family, anybody who might have a memory of where something once stood or something magnificent happened. Through her writing we have the power to envision Hanover's past. We can see Edmund Sylvester standing up at town meeting pledging support for a new high school. We can see E.Y. Perry's mind whirring as he schemes to bring a railroad to town. We can look inside country stores in West Hanover, South Hanover and North Hanover, when towns were little more than collections of villages. And we can see Charlie Gleason and

his peddler's wagon bumping through town, stopping to do odd jobs for longtime friends.

And thus, when Barbara passed away in November 2016, the Hanover Historical Society knew that there was no option but to properly memorialize her through a collection of her own stories, tales she told not only on paper but also in person to visitors to the Stetson House, people who joined her on walking tours of the cemetery or those privileged to call her teacher. We knew the best way to memorialize Barbara was to let her do so in her own words.

If there's one thing that Barbara repeatedly told us, it was to love our hometown. Yes, we are more transient these days than we were in decades and centuries past, and not all of us grew up here, but Hanover is a town worthy of pride. Our town center retains its historic character, and many of our most important natural sites have been preserved in perpetuity. To that end, she implored us to get involved. Join the Hanover Historical Society. Volunteer for events around town. Bring stories from the past forward, and remember that today is tomorrow's history. In 2016 and 2017, our attention has focused on the refurbishing of our cherished town hall, the clean-up of the Fireworks site, the closing and reuse of the Sylvester School and whatever is going to happen to the Hanover Mall in the years to come. In 2027, we will celebrate the 300th anniversary of Hanover's founding. Will we be ready for it?

Thanks to Barbara Barker, we'll be more ready than we know.

HANOVER HISTORICAL SOCIETY
September 2017

ACKNOWLEDGEMENTS

In a weird way, we have to thank our former selves. Barbara Barker loved the archival materials held at the Hanover Historical Society's Stetson House, items that were gathered by generations of members who knew the value of a collapsible tin cup, a half-hull model or a locally made plow. They inspired Barbara's love of Hanover, and for that, we, the current officers, directors and members of the Hanover Historical Society, are grateful. We thank the *Hanover Mariner* for understanding the value of a regular series of historical articles and providing a forum for Barbara's work.

Barbara's family shared her passion for history. Her husband, the late H. Stuart Barker, served as a past Hanover Historical Society president, and her second husband, Wally Kemp, joined her on her adventures of curiosity during the final phase of her life. It's with Wally's blessing and that of Barbara's daughter Libby Ritchie that we are proud to publish this collected work of our beloved Hanover town historian. Unless otherwise noted, all images are courtesy of the Hanover Historical Society.

HANOVER THEN AND NOW

The first family to settle in the bounds of Hanover was that of William Barstow, who came up the North River from the coast at Scituate in 1649. He settled near the river in the area now referred to as Four Corners. He was a husband, father, farmer, bridge builder, shipbuilder and keeper of an ordinary, among other things. Others followed him seeking more land, and by the early 1700s, there were two hundred families who petitioned the Massachusetts General Court to separate from Scituate and incorporate their own town, to be called Hanover, in 1727.

In his *History of Hanover*, John Simmons suggests that the name *Hanover* was taken by those loyal subjects of the king of England, George I, who, before ascending the throne of Great Britain, had been elector of Hannover. Simmons goes on to say that the difference in spelling can be accounted for by the "inclination, which has always been prominent in this country, to make improvement in every way upon everything."

Lucy Bonney, one of the authors of *Houses of the Revolution*, offers this description of town life at the time of the Revolution:

> *In the vicinity of the North River Bridge, where shipbuilding had been conducted for over a century, there was the largest settlement. At each of the old and new Forges, there were a few settlers. The little streams turned the wheels of several sawmills and gristmills around which a few homes had been built. There was an ordinary at the bridge, taverns at the Four Corners and one at Drinkwater.*

The rest of the town was covered by self-sustaining farms. Each was a large clearing where had been built a sturdy house of superb architecture. Beyond were the barns for horses, cattle, sheep and oxen. There were gardens and orchards, which provided food for the family and the farm animals, flax for the weaving of linen and herbs, as there was no doctor is town. Farther on were meadows and pasture land surrounded by stonewalls and hayfields. Beyond the clearing was an extensive acreage of woodland, which provided fuel for the great fireplace and lumber for building. "Only a few main throughways existed: the Country Way from the North River Bridge toward Boston, the Town Way to the Forges, the Drinkwater Way over Tumble Down Hill to the Abington line and Curtis Street from the Center of town to the North. Many little woodland lanes led from house to house or to the main road. Some later became streets, others can still be found in wooded areas.

"Many of the old homes are now here, some inhabited by the descendants of the early builders. Others are gone, but many a long forgotten house can be traced today by a lilac bush still blossoming near an old broken foundation or a nearby stonewall.

"Much of the old charm has disappeared, but that which remains is still beautiful."

Throughout the years that followed, changes gradually occurred. More houses were built, the district schools were turned over to the town and later consolidated, a high school was begun in the town hall, a railroad and trolley came and went. Many of the farmers and shipbuilders became shoemakers; doctors came to town. Electricity and the telephone arrived at the turn of the twentieth century, and the automobile followed.

It was the last three advances that changed life in our rural town. The end of World War II saw a burst of building, and later the Southeast Expressway resulted in Hanover changing to a suburban community with many fine new homes (although the old ones are the jewels). The town boasts of a fine educational system, a fine preschool and kindergarten program, two elementary schools, a middle school and a high school that sends 89.5 percent of its graduates on to higher education. The public library is well used. There are six churches and many civic clubs and organizations. Old volunteer fire companies once existed in the villages, but there is the most modern equipment and a permanent force at the center station. The police force is well educated and one of the best on the South Shore.

Business has moved much of its focus from the mills along the streams and the Four Corners to Route 53 and the Hanover Mall. But Hanover

Center received a Historic District nomination and still retains a pastoral feel, featuring the Congregational church, the parsonage, the town hall, the library, the Stetson House, the Civil War monument, the cemetery and the Sylvester School. Nearby is Briggs Stable, with horses prancing around the ring and riding along nearby trails. One can almost imagine that time has stood still here. Most of all, Hanover has always had people who loved their families and their town, supported education, had a strong value system and a spirit of volunteerism. Hanover people are proud of their town.

WHERE IT ALL BEGAN

HANOVER FOUR CORNERS

The Four Corners area is located at the intersection of Washington Street and Broadway, two of the oldest roadways in the town. This intersection is just a short way from an early North River crossing, which forms the eastern boundary of Hanover and Pembroke.

William Barstow, the first settler in the area that is now incorporated as Hanover, came up the river from Scituate in 1649 and built his house just across the Third Herring Brook and to the west of Broadway, behind where Oakland Avenue is now located. Here were the trees for building his house, nearby salt marsh hay and the river that would provide fish, transportation and a place to build ships. He built the first bridge over the North River on Washington Street in 1656, located about one-half mile south of his house, and his shipyard, one of the earliest on the river, was located on the site of the present Washington Street bridge.

Soon, other settlers would follow. The oldest house still standing in Hanover is located at 168 Broadway at Four Corners. It was built before 1693, as in that year, its owner, Daniel Turner, a shipbuilder, conveyed it to his son. Many fine old houses remain in the Four Corners, some replacing seventeenth- and eighteenth-century ones.

Four Corners developed as the early business center of Hanover because of the early shipyards located nearby. Also located here was the early

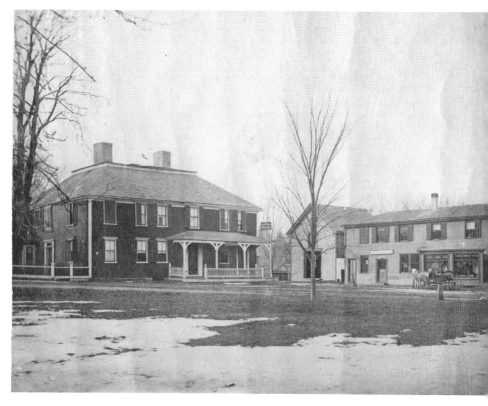

Today we see the Four Corners area as a quaint crossing of side roads, but in its heyday, it was a bustling town center.

blacksmith shop of Matthew Stetson and later Malitiah Dillingham. There was always a blacksmith shop located somewhere in the old village, the last one being that of Jim Jones, who worked shoeing oxen for forty years. When did you last see an ox?

It was at the tavern at Four Corners that the stage stopped on its way from Boston to Plymouth to Sandwich. The first tavern/hotel that operated in the busy Four Corners area was called the Wales Tavern. Legend has it that Paul Revere slept in a room here when he came to install officers at the new Masonic Lodge. The tavern was built in the early 1700s, when many shipyards were going full blast.

The Four Corners was a busy place with upward of four hundred workers at the height of its prosperity, and an inn was indispensable for hospitality and a cup of good cheer. The Hanover Hotel, built as early as 1797 and later known as the Howard House, stood where the parking lot opposite Mary

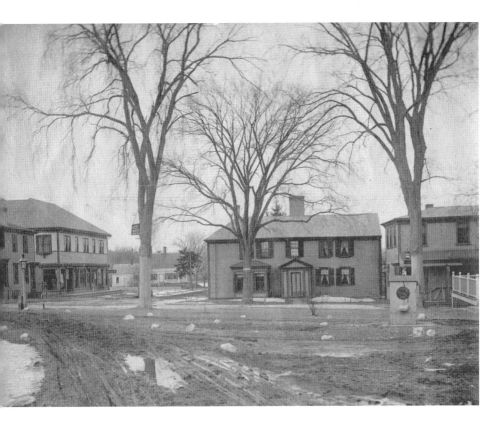

Lou's News is now located (211 Washington Street). When it was torn down, after the automobile became king, a gas station took its place. Of course, that, too, is gone.

The Josselyn Hotel was located about where Lorraine's Cake and Candy Supply is now, 148 Broadway. It was built as a farmhouse in 1856, at one time was used for lodging students at Hanover Academy and later for other guests. It was torn down after World War I. It is difficult for us to imagine hotels in the sleepy village of Four Corners today. Beside the Wales Tavern is the building that began as the original Hanover Academy building. A private institute operated in the building from 1808 to 1818, when it was located in Hanover Center. The building was moved here soon after and has been used as a tavern, store, post office, lodge, hall, telephone central office, shoe shop, drugstore, dentist parlor, woodworking shop and antique store. A new academy building was constructed on the site of Salmond School in 1828. That building was sold to the town when the academy disbanded and replaced by the present Salmond School in 1931.

Chippy Curtis, who operated a drug and variety store in the Academy building, was a Republican, and John Flavell, who had a general store on the opposite corner, was a Democrat. The two shared the office of postmaster, and the post office was located in one or the other building depending on whether the Republicans were in office or the Democrats were.

At different times during its history, various grocers operated in the structure. Also located in the village during the early 1900s were barbershops, a millinery shop, Belle Tucker's dry goods store, a restaurant, a photographic studio, a funeral parlor, a justice of the peace office, a flower shop, a Chinese laundry, a livery stable opposite the railroad station and Phillips Bates's coal and grain company.

In 1926, a block of stores was built on the site of Josselyn House, and several chain grocery stores were located here. In the early 1930s, Columbia Road and a new bridge over the North River were built, and the busy village of Four Corners was bypassed by the Cape traffic. Many were glad, but the business community suffered and life at the Corners changed forever. Those who live in the neighborhood today enjoy their quiet, quaint village.

THE SYLVESTER MANSION HOUSE

(The numbers in parentheses refer to the numbers in the genealogical section of the 1910 History of Hanover, *which help generations of a family to be identified.)*

The stately home at 417 Washington Street was called the Sylvester Mansion House to distinguish it from two other old, smaller houses nearby owned by Sylvesters at one time or another. All three houses are now part of the Cardinal Cushing School property, acquired in 1935 from the Mitton family, which ran a gentleman's farm called Elmwood and sold milk and cream from special Guernsey cows.

In the early 1930s, Washington Street was straightened. The new cutoff extended from the end of Old Hanover Street to the top of the hill in Pembroke and became Columbia Road, part of the State Highway, now Route 53. This necessitated a new bridge, the one currently standing. The old part of Washington Street on which these houses and others were located was just bypassed, and the Four Corners area stopped growing as a business center.

The Sylvester Mansion House served as the Hanover home base for the Sylvester family, many of whom were named Robert.

Amos Sylvester, who was married in 1706, came into this property through his father and built a small house here in which he kept a tavern. He was probably a farmer as well and a good businessman. Amos had 11 children, and his son Michael inherited the land and house. The original house (tavern) burned in 1762. Michael and his second wife built the larger, typical center chimney colonial in 1763. Although Michael was over sixty years of age at the time of the Revolution, he did his part, going to Cohasset on the alarm there, taking three trips to Rhode Island and, in 1776, journeying to Ticonderoga. Michael died in 1789, and his youngest son, Robert (16), born in 1772, inherited one third of the estate, which included this house. Robert's son Robert (22), who was only two at the time of his father's death in 1807, inherited 80 acres and the homestead farm with buildings at his mother's death in 1840.

Robert Sylvester (22) was an interesting and long-lived man. He became known as "Old Robert" to distinguish him later from four other Robert Sylvesters who lived in the Four Corners area in the 1890s. His son Robert (30) was called "Little Bob," and Little Bob's son, Robert (30i) (of course), born in 1871, was called "Young Robert." "Bob Mike" was the name for

Michael Robert Sylvester (27), who built 167 Washington Street, and his son Robert Irving Sylvester (27vii) was known as Irving. Bob Mike was killed in the terrible fire at Four Corners in 1898.

Robert Sylvester (22) lived in this mansion house for many years. He married in 1828 and had seven children. In 1860, when a valuation of all property in town was published, it appeared that Robert Sylvester owned considerable property, including the "Tiffany farm, the Palmer farm, the Edmund farm. 2 horses, 2 oxen, 9 young stock, 3 swine and 17 sheep." He also had $15,000 worth of bank stock and $4,275 in railroad stock. When most valuations at that time were under $2,000, Robert Sylvester was well off. When Robert (22) died in 1899, he left his youngest son, Robert (30), his gold watch and his homestead farm, with 140 acres of land held in common with his brother Michael and a cousin, Edmund Q. Sylvester. Robert (30), "Little Bob," only had one son, "Young Robert," who died at age twenty-four in 1896.

Robert (30) moved from the mansion house about 1905. The house went out of the family about this time. The property with the smaller house next door was purchased by Colonel John Osborne, and later, through the Rockland Trust Company, it passed to the Mittons. About 1947, the mansion and the smaller house, called "Iron Kettle Inn," were presented to the Sisters of St. Francis by Archbishop Cushing to be called St. Coletta's School. In 1970, the name of the school was changed to the Cardinal Cushing School and Training Center. The school is known nationwide as a model for training children with special needs to become useful citizens of the community. Hanover is proud of this part of our modern town history.

LOTTIE PETERSON'S STORE

Lottie Peterson's store was located on Broadway and what is now the corner of Columbia Road, long before Columbia Road was put through around 1930 or so. Just a few hundred feet south on Broadway was the Hanover Depot, and to the north on Broadway was the Odd Fellows Hall.

Charles A. Peterson came from Duxbury to Hanover in 1887 and brought with him his partner, Frank Davis, with whom he was in business at Powder Point. They set up a shop in Robert Dwelley's yard. After three years, Davis sold out and went to California. The building was moved, and Charles Peterson bought land off the Odd Fellows.

Peterson built a large Victorian house. He was one of a dozen in town who had a windmill to pump water. Peterson was a dealer in stoves and hardware and quite successful in business. He and his wife and daughter, Lottie, lived upstairs over the store. Then, in 1898, came the tragic fire at the Four Corners. It started in the basement of the Bates Store, which was located in the area where the Phoenix Lodge now stands. As reported in the 1977 *History of Hanover*, on November 11, 1898, Mrs. John Flavell was up tending a sick child and saw a glimmer of light in the basement of the Bates building. Realizing that it was the start of fire, her husband ran down to the house of the fire warden, Dwelley, who rang the alarm, and the neighboring men responded, including Peterson.

Suddenly, without any warning, an explosion occurred. A number of firefighters and neighbors, badly injured, were taken out, but three remained buried and burned beyond recognition. One of these was Charles A. Peterson. It was a sad day in the history of Hanover.

The widow of Charles Peterson and her daughter kept his store running for a while but soon leased the store to others, including Henry Magoun, who ran a stove business and remained there until 1915. At that time, Miss Peterson remodeled the store into a tenement for the convenience of Belle Tucker, who kept a dry goods business there for some time. In an old picture,

The term "convenience store" had not been coined in Lottie Peterson's day, but neighborhood stores like this, in the days of horses and buggies, tried to make shopping as convenient as possible for all local residents.

one sees a patient man and horse waiting for someone (must be a female someone) outside the store. One can see vines growing up along the outside staircase to the living quarters above the business. In another view of the house, one can see the Odd Fellows Hall, which was built in 1888.

In the early 1930s, Columbia Road was put through from where the VCA Roberts Animal Hospital is now located, to the west of the Four Corners, through the Sylvester fields, and a new bridge was constructed over the North River. This new road divided the Charles Peterson land and the Hanover Branch Railroad Station so that each stood on opposite corners of Columbia Road (now Route 53). The Peterson house has seen many changes, and now several medical offices are located here, but the exterior is much the same, with many of the Victorian touches still intact.

BACK STREET HOUSE, HOME TO MANY PROFESSIONALS

The large, gracious house located on Back Street, now 94 Oakland Avenue, was constructed from the timbers of the first Episcopal church in Plymouth County, which stood a few hundred yards north of the Third Herring Brook in the present Norwell at the central part of Church Hill. Behind the church on the hill is one of the most interesting old local cemeteries. When the old church proved too small and inconvenient for its growing congregation, the "new" St. Andrew's was built in 1811 at the Four Corners at a cost of $5,000. The old building was sold to a man of the times as well as a man of the cloth, Reverend Joab Cooper, for $188.82. (I wonder what the 82 cents was for.) He took the old building down and, with its timbers, had the present house built, which became the rectory for a few years.

In 1940, Charlie Gleason said, "This is perhaps the best built house in Hanover, as the quality of the lumber would be impossible to match nowadays." Charlie later did a lot of work on this house for Mrs. McCullough, a past owner, and he had seen the sturdy construction firsthand. The present house stands on the site of an earlier house on land of the first settler, William Barstow. Thomas Sylvester, who was born in 1723, probably built the first house here, and it was later occupied by his daughter, Margaret. In 1811, Reverend Cooper then built the two-end chimney colonial on the site of the old Sylvester house. Thence began a chain of several ministers and doctors who made this fine house their residence.

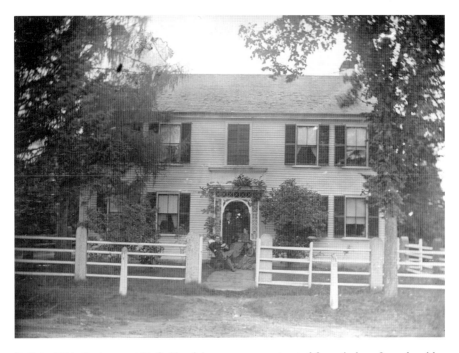

Built in 1811, the house at 94 Oakland Avenue was constructed from timbers from the old Episcopal church.

Reverend Calvin Wolcott, who served as rector of St. Andrew's from 1818 to 1834, served as principal of Hanover Academy for a year. He also taught private pupils in an attic room in the house, and some Latin words—inscribed, no doubt, by some scholar—are still evident. During some of the time between 1834 and 1849, there were supply rectors who served for short periods and no doubt lived in the rectory. Dr. Jacob Richard married Reverend Wolcott's daughter, and they resided here briefly. In 1849, a new rectory was built at 288 Washington Street for the ministers at St. Andrew's, and Reverend Wolcott sold the old rectory to Dr. Joseph Forbes. Dr. Forbes practiced medicine in Hanover for thirteen years and lived in the Back Street house. Dr. Alfred Garrett succeeded Dr. Forbes in the practice of medicine and was an occupant of the house for twenty years. He was followed by Dr. John O. French, who also lived here for a short time before moving closer to the river.

Dr. French is described in Dwelley and Simmons's 1911 *History of Hanover*: "He had a strong constitution and great powers of endurance; was a cool and skillful operator, working often day and night without rest."

Dr. Nathan Downs came to Hanover before 1869 and also lived here for a few years. At some point, E.Y. Perry, the founder of the Hanover Branch Railroad, Phillips Bates Company and a dozen other businesses, purchased the property in 1879. He traded houses with James Tolman of Norwell in 1886. Tolman's daughter, Morgianna, became a schoolteacher and taught in Hanover, Norwell, Abington and Rockland for fifty years and lived out her life in this house, which became known in her time as the "Morgianna Tolman House." Her brother became a professor of Greek at the University of Tennessee.

Mrs. John McCullough lived here for many years and cared for it well. She noted that Gleason, when shingling the ell, found where the original entrance to the rear of the home was located, and concluded that the present butler's pantry and dining room were originally one large room. A back staircase was located where a laundry chute is sited. These old houses have seen many changes and many occupants. If only the walls could talk.

A BEAUTIFUL OLD HANOVER HOUSE

Smith, Salmond, Sylvester, Harraden, Hatfield, O'Brien—well-known names in Hanover's history, and they all have a history in a house located at 128 Washington Street facing the wonderful open Sylvester Fields and beyond them the North River. The aforementioned families all lived here and influenced the history of our town.

This house, built about 1810, replaced an earlier house on the same site built about the time the town was founded and described as "two stories in the front, sloping back nearly to the ground." Albert Smith, born in 1763, tore down this old house and, sometime between 1810 and 1814, constructed this clean-lined central entrance colonial. Smith had interests in shipbuilding and served as a representative and senator from this district. He lived most of his adult life in a large house on Broadway. He was a man of some means, and the Washington Street house was given to his daughter Elizabeth and her husband, Samuel Salmond, and here they lived and raised their family.

Samuel Salmond was a good businessman. He was engaged in the tack business and accumulated a considerable fortune. The Salmond family was generous to the Town of Hanover, giving money toward Sylvester School and financing Hanover Academy and the Salmond School. Salmond's eldest daughter, Mary, born in 1832, married wealthy neighbor Edmund

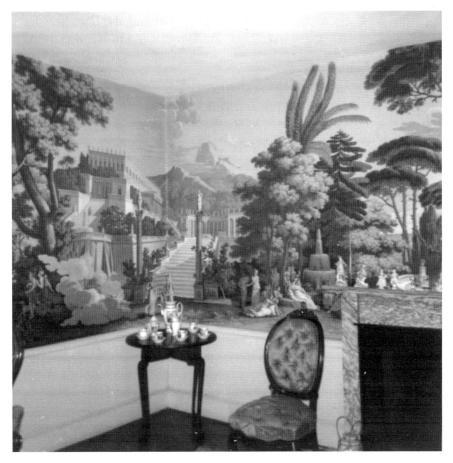

The wallpaper in the house at 128 Washington Street was so rare, it ended up being removed and preserved by the Society for the Preservation of New England Antiquities, today's Historic New England.

Q. Sylvester in 1858, and they moved into the fine mansion he had built just up the road. She died in 1864, and Edmund married Mary's sister Eliza in 1867. The eldest daughter of Edmund Sylvester and Mary, also named Eliza, born in 1861, married Reverend Frank S. Harraden in 1893. He was the rector of St. Andrew's Church, and they lived in the house where her mother was born.

Reverend Harraden died in 1905. Later, Eliza Sylvester Harraden married Dr. Hugh Hatfield. Dr. Hatfield, a graduate of Harvard, held joint degrees in medicine and dentistry and was one of the first orthodontists in Massachusetts. He practiced in Boston and summered in Hanover. It was

during the Hatfields' residency that some very unusual wallpaper was put on the front south room. It told the Greek story of Telemachus and how he went from Troy to Ithaca, looking for his father, Odysseus, who had died in the Trojan War. The wallpaper was so unusual and valuable it was removed and preserved by the Society of the Preservation of New England Antiquities.

Mrs. Hatfield died in 1942, but Dr. Hatfield continued coming to Hanover in the summer season. Fred Saunders was the caretaker of the house for the Harradens and Hatfields for many years and was a well-known character in the Four Corners. John and Janet O'Brien purchased the house in 1971 after Dr. Hatfield's death. The house had no children living in it for one hundred years. The O'Briens changed that when they moved in with their four daughters and soon became involved in the community. Janet served on the Planning Board, became our first woman selectman and went on to become the state representative for this district. Dr. O'Brien kept a busy practice as a respected physician in South Weymouth.

Hanover has many fine and beautiful old homes. I have been inside over one hundred of them and admired the old fireplaces, paneling, unique staircases, wonderful beams and such. Some people have expressed surprise that Hanover has so many wonderfully preserved homes, but Hanover was founded in 1727, and the town was well settled by 1849, when over 250 homes were placed on a map of the town made at that time. Of course, some have been destroyed, especially along Route 53, and it behooves us all to respect and preserve those that remain, because we not only preserve the house but the history that it holds.

THE ODD FELLOWS HALL

Natives of Hanover remember the Odd Fellows Hall. Built in 1888 on the south side of Broadway next to Academy Avenue (now the driveway to Salmond School), it was the home of the North River Lodge of the Independent Order of Odd Fellows. At first, the Odd Fellows met in rooms above Bates' Store at the Corners, but the organization later constructed this building.

Charlie Gleason said that at one time there were two hundred active members. "Time was when this lodge building was the center of considerable interest and activity. I recall when I joined in 1905, members drove several miles to attend the Monday night meetings. We had many members coming

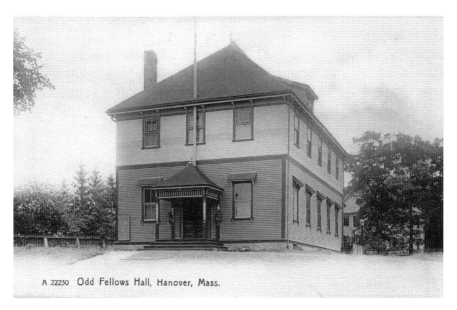

A 22230 Odd Fellows Hall, Hanover, Mass.

The Odd Fellows Hall was a gathering place for people from Hanover and beyond, but it lost prominence as membership waned and was torn down in 1960.

from Marshfield, Norwell, Pembroke, and Hanson drive in with horse and buggy or with sleigh in winters. There was a large horse shed at the rear of the building, and some put up in Hiram Howland's stable."

It was the custom in later years for the members to attend services as a group once a year at the Congregational church in the Center to observe Memorial Day. One picture shows a group about 1940, including Robert Montgomery, Elmer Turner, John Reskervich, Samuel Turner, William Taylor, Alvin Dame, Wallace Cossaboom, Merton Studley, Bernard Stetson, William Flynn, Whitman Soule, Alfred Anderson, Chester Kiley and Eugene Phinney. Charlie Gleason took the picture and served as chaplain for 40 years. Others members included Ted Sykes, George Little, Reverend Barclay and Lawrence Sweeney.

The Odd Fellows Building served not only as a meeting place for the lodge but also as a place for community events. There was a stage as well as a dance floor. Here were held public meetings, debates, children's dancing classes, plays, concerts, movies and adult dances. Dancing was a common entertainment at the beginning of the twentieth century. There were balls held at the town hall, on the top floor of the old Academy Building, at Library Hall in West Hanover and here. People loved to dance.

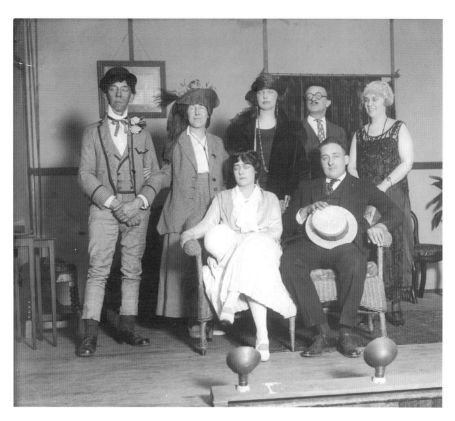

More than a meeting place, the Odd Fellows Hall provided entertainment. Here, a cast of characters from a 1920 play pause to be captured for posterity.

Eventually, membership in the lodge dwindled. Charlie attributed the decline to "coming of the automobile, motion picture theaters, radio, television." The building fell into disrepair, and the members of the lodge dispersed and transferred to other lodges and died. When the lodge folded, the building was sold to the town for $7,000. But though the building was used for some community events, there were several fires, and the building remained idle and became a hazard. It was torn town in 1960 and the land taken over by the town for parking for the Salmond School. Charlie regretted the loss of the building but was philosophical: "This is the way of the times."

We are all indebted to Charlie Gleason as a preserver of stories and pictures of old Hanover. When he came to Hanover in 1905 as a young man of twenty-five, he brought his innate intelligence, his interest in people and his ability to take a picture and tell a story. He made scrapbooks of his

pictures and stories, and the historical society is fortunate that several of them have been passed on to them. Charlie Gleason was a true historian, and because of him, much of our everyday history has been preserved. Charlie was an "odd fellow." Would that there were more like him.

One Old Hanover Inn with a Colorful Past

The Howard House was also known as the Hanover House or the Four Corners Inn, depending on the ownership. It was located in the historic Four Corners area on the corner of Broadway and Washington Street. The site is now a parking lot owned by the Phoenix Lodge and also used by patrons of Mary Lou's News. The inn was torn down about 1925 to make the corner wider for the automobile, which was making an impact on this sleepy village.

It was built by David Kingman probably about 1750 and used as his residence. As it was being torn down about 1925, Charlie Gleason noted that "the early siding and roof board laid vertical instead of horizontal and the laths for plaster made of thin boards partly split and the cracks opened leaving the open crevices for the plaster. The old boards were hammered together with four-inch hand-wrought nails. Bricks for the old hive oven and two chimneys were made on the Hanover side of the Jacobs Pond."

Yankees being what they were, I wonder who salvaged some of the relics of this old building. Records show that as early as 1797, the building was used as a tavern/hotel, and in the dining room of the building, the county court sat for meetings well into the 1800s. In the days of Daniel Webster, he found it a favorite stop for beefsteak dinners on his weekend visits to his

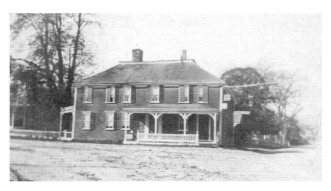

The building generally called the Howard House served as a hotel from the late 1700s into the early 1900s, an easy convenience for visitors stepping off the train just up Broadway.

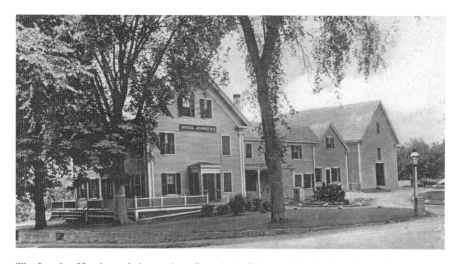

The Josselyn Hotel stood about where Lorraine's Cake and Candy Supply stands today, another sign that Four Corners was once a thriving community center for Hanover.

home in Marshfield. The stagecoach went by the door in the early days, so the inn was a place to stop for refreshment.

By 1870, when the Hanover Branch Railroad was up and running, the station was only a block away, and the Hanover House was a convenient layover for salesmen and such. Charlie Gleason recalled that through its colorful history, the rooms fulfilled various uses: "a residence, tavern, dance hall, court room, tailor shop, tinsmith shop, meat market, telephone exchange, dry goods store, millinery, barbershop, post office and, to anyone who visited Joe Tripp's back room, a museum." Joe Tripp was the last proprietor and son-in-law of Frank Howard, whose name was used to describe the hotel during his ownership.

The Four Corners Inn is probably most remembered as the hotel that employed as its manager one James Costley, who was hanged in 1875 for the murder of the chambermaid Julia Hawkes.

MURDER AND AN UNMARKED GRAVE IN HANOVER

It was a dark and stormy night—so begins many a mystery. This is a tale of murder, most foul, when on the dark and stormy night of May 23, 1874, the body of a young woman, wrapped in a carriage robe and weighted down with a heavy object difficult to identify, was thrown into the turbulent waters

of the river on the Weymouth-Braintree line. Sunday morning, May 24, what appeared to be a large bundle was dragged to shore and the shocking discovery made—the body of a woman between twenty and thirty years of age with dark hair, dressed in black with one red shoe and one jade earring, was revealed. She had been shot in the head.

Who was she? Where was she from? Who murdered her?

These were the questions to be answered. And the answers were to be found in Hanover. State Constable Napoleon Bonaparte Furnald, a short, mustached man, was assigned to the case. He was a tenacious fellow and determined to solve the crime. His clues were a carriage robe with a metal tag attached to one corner, the strange, heavy piece of metal used as a weight and a missing red slipper. Coroner George W. White had determined that death was probably caused by a gunshot wound, fired at close range, later identified as a .45-caliber Smith and Wesson. While questioning the gathering crowd on the riverside where the body was recovered, Furnald heard from a blacksmith that a carriage had stopped on the bridge about midnight during the storm and then, after a pause, started up again. Another onlooker identified the iron piece as a tailor's goose, a long, heavy, oversized iron used by tailors in pressing suits. Perhaps the murderer was a tailor.

The newspapers picked up the story of the unidentified young woman who was found murdered and pulled from the river. On Monday evening, two women appeared at the Weymouth police station inquiring about the body. A friend of theirs by the name of Julia Hawkes had been missing for a few days, her whereabouts unknown. Could the body be that of their friend? They hoped not. But when taken to view the remains, they were shaken. Indeed, it was their friend Julia Hawkes, a young widow from New Brunswick who had come to the area with a small inheritance and was working to purchase a house and make a new life for herself here. Mrs. Hawkes had recently left a job as head housekeeper at the Four Corners Inn in Hanover, as the inn had closed due to liquor violations.

Detectives were sent off to Hanover to make inquiries there. Meanwhile, Napoleon Bonaparte Furnald was questioning the stables in the area, trying to find the identity of the metal clip, similar to the one found on the carriage robe in which the body was wrapped. At the fortieth stable, Reidell's in Boston, Furnald found what he was looking for. "Yes, that is one of our disks," said Reidell. Searching his records, he revealed that he had rented a rig with that number that to a James Costley of Hanover on Saturday, May 23, and it had been returned in the early morning hours of

the twenty-fourth. Furnald examined the carriage, which had not yet been cleaned. Behind the seat was wedged a crimson slipper that matched the one found on the body of the now identified Julia Hawkes. Furnald was closing in.

Down to Hanover on the Hanover Branch Railroad went State Constable Furnald and two assistants. They found the Four Corners Inn easily and were told it had previously been called the Howard House after the former owner, who had also been a tailor. Entering the inn, they came upon the handsome James Costley, hastily packing his bags. "I'm in a hurry," he told the detectives. "Got to catch a train." He never did catch that train. He was caught instead by his own lies and evidence that was found in the attic of the inn.

An outline of the unusual tailor's goose was found in the dusty attic, and gunnysacks similar to those used to wrap the iron were found there also. An envelope of bills matching the denominations of those withdrawn by Mrs. Hawkes was found in Costley's pocket. When trapped by this evidence and lies about his whereabouts, Costley drew a pistol, the same caliber as the murder weapon. He was swiftly disarmed, but his goose was cooked. It was uncertain where the murder took place: in Hanover or somewhere on the road between Hingham and Weymouth. The decision of where the trial should take place set the legal precedent that a case should be tried in the county where the body was found if there was no clear evidence where the murder was committed. The trial took place in Dedham, and Costley was convicted of murder.

For a while, the people of Hanover could not believe this "hail fellow-well met" could be guilty of such a crime, but other facts emerged about the disappearance of two other chambermaids, one found poisoned, and the simultaneous engagement to a wealthy Hanover heiress. Soon, the people of Hanover were disdainful of Costley, and although tickets were given out for the well-attended execution, not many Hanover residents were present. Costley declared to the end, "I am not a murderer!" His body was taken to Hanover Cemetery and buried unceremoniously. Although the grave was not marked by a gravestone, it is said that residents cast their own stones over the grave until they formed a mound under an old maple tree. Grass now covers the spot where James H. Costley, murderer, lies buried.

MURDER AT FOUR CORNERS

Most residents of our fair town haven't heard of the infamous event that made the Boston papers in 1904. The operator of the Chinese laundry, located on the first floor of the present-day Phoenix Lodge, was murdered in cold blood in broad daylight. Who could have committed such a dastardly deed? This was the question answered at one October meeting of the Hanover Historical Society held at the very site of the murder.

Back at the beginning of the twentieth century, the quaint village of Hanover Four Corners was a busy gathering place, connected to other parts of the town and to the city by the Hanover Branch Railway, which ran ten trains a day from 6:00 a.m. to 6:00 p.m. In addition to the railroad station, there was a livery stable, a blacksmith shop, the old Salmond School, St. Andrew's Church, two hotels—one of which contained the new telephone office—the post office, a barbershop, two grocers and a Chinese laundry. One grocery, the barbershop and the Chinese laundry were located on the lower floor of the Masonic Lodge building. This was the setting of one of the most famous murders in the county's history.

Quong Sing, the operator of the laundry for two years and well thought of in the village, was murdered. Who could have slain such an honest, hardworking man? A docudrama written by Barbara Barker, local historian, introduced the main characters of this story, and then the amazing tale was acted out by members of the historical society. The part of Quong Sing was realistically played by Pauline Rockwell, a young woman of considerable talent. Her husband, Rick, played the part of Cyrus Ryan, an employee of the Clapp Rubber Mill who had been seen the morning of the murder skulking about and then left town quickly on the 2:15 train to Boston that day. Quong Sing was found drowned in his laundry tub, his head held down by a wooden soap box. The grocer and the barber had noticed the stranger lurking about during the morning. Early in the afternoon, they found their friend, Quong Sing, apparently murdered, drowned in his laundry tub. The grocer was played by Roger Leslie, owner of Leslie Foods, and his wife, Susannah Leslie, was called in at literally the last minute and played the part of Snell, the barber, with good humor.

On discovering the body, they immediately notified Police Chief D.H. Stoddard and Selectmen Waterman and Bowker. Boston authorities were also notified with a description of the man to watch out for, the suspect who had been seen boarding the 2:15 train. In the meantime, medical examiner Dr. Henry Watson Dudley, played by historical society vice president Les

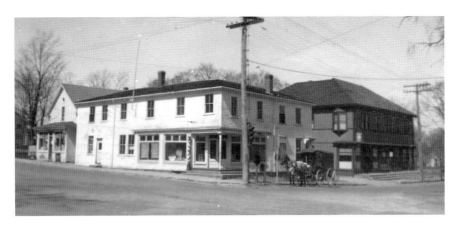

Bates' General Store stands in the foreground; just to the right is the Phoenix Lodge, where Quong Sing was murdered.

Molyneaux, was called in to conduct an autopsy. Dr. Dudley had the body removed and conducted a thorough examination and determined death was caused by drowning. As the suspect, Cyrus Ryan, departed from the train in Boston, he was held for questioning. On his person were found a revolver and a watch with a chain, both believed to have belonged to Sing. Ryan was arrested and held over for trial. The motive for the murder was believed to be robbery, which followed on the heels of two other robberies the previous day.

The audience was then asked to serve as the jury as a mock trial was held. Hal Thomas, a fairly new resident of Hanover with law enforcement experience, played the part of the district attorney. Donald Deluse, town moderator, played the role of the defense attorney and almost got his client off with his eloquence, suggesting that the victim had an enlarged heart and that the liquid in the lungs could have been caused by edema from heart failure, the result of heart disease. But Dr. Dudley's evidence was conclusive. In his thorough autopsy, Dr. Dudley had examined the liquid in the lungs of the victim and found it to be soapy water from a laundry tub, not the result of edema. The audience of over one hundred attending the meeting voted that Cyrus Ryan was indeed guilty of the murder of Quong Sing, and their verdict agreed with the jury of history.

Ryan was sentenced to life imprisonment. Other participants in this entertaining drama included Carol Franzosa, president of the historical society, as narrator; Barbara Barker, researcher of local history, as Miss Hannah Jones, fictitious visitor and describer of the village; Joan Thomas,

society member, as the fiancée of Cyrus Ryan; and Judy Grecco, society member, as stage manager. Newspaper articles concerning this historic event had been saved in the files of the historical society, and further research from files from the *Rockland Standard*, the *Boston Herald* and the *Bryantville News* added to the primary sources. The information concerning Dr. Dudley's thorough investigation was discovered by Les Molyneaux in an old book he had in his possession honoring Dr. Dudley. The audience thoroughly enjoyed this creative and unusual program about an event in the history of our town. That the presentation was held at the site of the murder added to the mystery of the evening.

THE SECOND CONGREGATIONAL CHURCH

Recycling is a new word for an old Yankee practice. Nothing was ever wasted in earlier times. "Make it do, use it up, do without" goes an old proverb. Leftovers were recycled into casseroles; clothes were handed down, remade, used as quilt pieces and for dust cloths; even buildings were moved or the wood and materials saved to be used again.

Such was the case of the Second Congregational Church. Although commonly referred to as the Second Congregational Church, it was at first known as the Congregational Trinitarian Church of Hanover. It was also called the Orthodox Church. Many do not know that this typical white New England church with its fine bell and tall steeple stood on Oakland Avenue (then called Back Street) near the Four Corners from 1854 to 1936. It began its history as a Baptist church in Abington. As Charles Gleason told the story, "There was a squabble in the Center Hanover Congregational Church over one thing and another, and about the same time many of the members of St. Andrew's Episcopal got peeved and together these assorted members got together and bought a meeting house in Abington and moved it here."

The records of the First Congregational Church of March 15, 1854, show that thirty-two members were dismissed to form a new church "which would be an accommodation to the Hanover people who lived near the Four Corners." The view from the steeple looked out over the village of Four Corners and over to Church Hill in Norwell, where other members lived. The first minister retained was Reverend William Chapman. He had only served for one year when ill health forced him to resign. He was followed by Reverend Mann, whose salary was $600 a year. He only lasted one year. Then

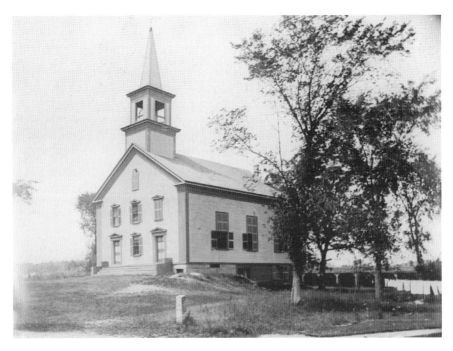

When the local congregation grew large enough, the First Congregational Church dismissed thirty-two members to form the Second Congregational Church of Hanover.

came Reverend Aiken, who remained twelve years, one of the longest terms held. (Maybe they paid him more than $600.) Then followed a succession of short-term ministries, until Reverend John Wild came in 1892 and remained until 1904. (One of his daughters married a Hanover man, Henry Barstow.)

Families with familiar names of Barstow, Tolman, Ford, Turner, Lapham, Stetson, Cushing, Damon, Sylvester, Eells and so on worshipped here for two or more generations. Gleason, himself, attended here for a time. A story is told of how the church bell would toll the years of a member at his or her death. One man borrowed a sum of money from another member (the bell ringer) and assured him he would pay it back. Time went by and promises were made, but the sum was not repaid. Finally, the bell tolled the death of the borrower, but he was seen on the street. When questioned, the bell man is said to have answered, "He took so long in paying I thought he must be dead."

Gradually, the older people died off and the younger ones moved away, and eventually, the church closed. It remained unused for a few years, but Yankees they still were, and in 1936, the church was torn down and moved by George Clark to his farm in Pembroke. He set the building up again

almost exactly as seen in old pictures, except for the steeple, and used it for a two-story pig house (How did the pigs get up to the second floor? A ramp?). At the time of its removal, a newspaper article (written by Charlie Gleason, I think) said, "[T]his spire has shown across the glades and forests in a gesture of gentlest dignity, pointing to the heaven of which men have dreamed.... [T]he old church bell is never again to sound out its call over the countryside far down the North River valley. Here is a note of recompense. The old bell is now installed in the tower of the Baptist Church, Woodstock, Vermont." From Baptist church in Abington, to Orthodox church in Hanover, to piggery in Pembroke, to Baptist church in Woodstock, the old building and bell have influenced many man and beast.

THE RED AND BLUE WAR OF 1909

Have you heard of the Red and Blue War of 1909? From August 14 to 21, 1909, the U.S. government, together with the state militia (and other New England states), planned a mimic war. Ten to twelve thousand men, under arms, invaded Hanover and nearby towns to participate in mock battles. Richard Harding Davis, a war correspondent present, wrote that it was as real as anything in an actual war, except no one was killed. Hundreds of great wagons loaded with provisions and camp kits came through our streets, blocking traffic, which at that time was horses and buggies. Many of the participants arrived on the extra trains put on the Hanover Branch Railroad to bring them to our town, which was the site of much activity.

The Blue were the defenders, and the Reds were designated as the enemy. Taken altogether, they were respectful, and many made friends. One of the largest encampments was located in the Sylvester fields, near the present Cardinal Cushing School. Many of the men were farmers, factory workers, shop keepers and the like and were unused to the rugged terrain and work. Some were called "tenderfoots." Some got lost as they charged the enemy through the swampy areas and didn't find their way out for two days. Many exhausted men were carried out on stretchers. Many begged food from the country folk because their camp was miles away. Some wells in Hanover went dry because of the demand for water.

One of the largest battles took place near the Four Corners area, in the field east of the intersection of Washington and Broadway. The men trampled planted fields like cattle as they charged the enemy. The heaviest

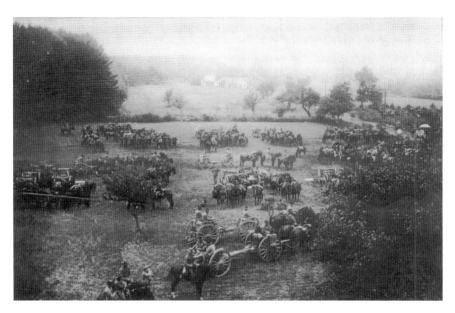

When the state found the need to conduct war games in 1909, it came to Hanover for the great Red and Blue War, played out here on the Sylvester Fields.

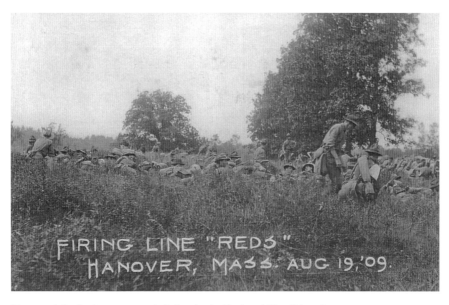

Troops of the Red army man their line in the Red and Blue War of 1909.

cannon fire occurred on the last day, when the two forces met on a nearby site. The detonation of the cannons set off on Broadway broke dishes from shelves in neighboring kitchens and broke every pane of glass in Herman Sturtevant's house (427 Broadway).

At the end of the skirmish, the men made their way back to their hometowns. Trains reached from Hanover (near Four Corners) to West Hanover. No doubt many of these boys fought in a real war a few years later, and many laid down their lives for their country.

THE CENTER

Hanover Center Circa 1900

Hanover Center is unique in that although there have been changes since 1900 or so, the town center today still maintains its rural atmosphere. Several buildings in the district, including the Stetson House and the Congregational Church Parsonage, were in place in 1900. The cemetery is appropriately part of the district. Listed in the Hanover Center Historic District also are the John Curtis Free Library, which was built in 1908, and the Sylvester School. The Sylvester School was built in 1927 on the site of an early district school. Both the library and the school are consistent in architectural style with the columns on the town hall and church and fit into the New England town center.

There has been little intrusion of business. Briggs Stable only adds to the pastoral feel of the town. There was a store on this property begun by Perez Perry probably in the early 1800s, taken over by Andrew Damon and inherited by Stanley Briggs in 1908. The center post office was kept here for some time and then moved down the street to Hanover Street. The town pump gas station evolved when the automobile became king and stands on the site of an early low cape moved to 49 Grove Street.

The present town hall was erected in 1863, replacing one located next to the church across the street. In 1862, the church caught fire and rapidly spread to the adjacent town hall. Both were burned beyond repair and

Hanover Center forms the heart of the community, with government, religion, education and even the Hanover Historical Society headquartered in the Stetson House, at left, all in one place.

replaced the following year, the town hall moving across the street. The 1863 town hall was built on land purchased from Henry Stetson. The architect was Luther Briggs, and the carpentry work was done by S. Nathan Turner.

We have in the files of the historical society the original specifications. The proposed cost was estimated at $11,390 to cover the finishing and furnishing expenses. This building consisted of only the center section of the present town hall. Education for high schoolers was provided in 1868, and rooms in this town hall building were used for that purpose. In 1893, a wing was added to each end of the original central portion and a meeting room in the back.

J. Williams Beal, noted architect and Hanover resident, designed the additions. The high school expanded, taking up more rooms, and the John Curtis Free Library collection of books was housed here until 1907. In 1977, the 250th anniversary of the town, a further addition was constructed. Brett Donham of Donham and Sweeney was the architect for the most recent addition, which included increased office space and a larger hearing room. Quarters for the police department were provided on the lower level, which it outgrew, and a new police station has been built.

In the lobby outside the selectmen's office and hearing room is a wonderful mural painted by artist Samuel Evans. It depicts scenes of old Hanover. If

you are interested in local history and haven't studied this treasure, mark it on your list of "things to do." The First Congregational Church shown in the photo was also constructed in 1863 after the disastrous fire. It stands on the site of the original Congregational church, which founded the town in 1727.

Another focal point in the historic district is the Civil War monument, which was dedicated in 1878. It was suggested at Memorial Day exercises in 1877 that a monument to honor the Civil War veterans be erected, and "the ladies—always first in every good work—should take the matter in hand, and by means of a Fair" should raise the necessary funds. And the ladies did. "The Fair was held in the Town Hall on Tuesday the 16th of October" and raised $1,248.22. John Williams Beal, local son, newly graduated from the Massachusetts Institute of Technology, designed the monument, and it was so constructed. The shaft and capital weigh over fifteen tons. A grand dedication was held that lasted all day and featured many dignitaries and over twenty speeches and such.

Hanover Center has been spared the intrusion of the Route 53–type commercialism and still maintains its pastoral small-town feel. The state constructed brick sidewalks in the district, tying it all together. Signage marking the center as a National Historic District was proposed on a town warrant and erected. Hanover people are proud of their heritage, which began here in the town center and continues to the present day.

BRIGGS STABLE AND HOUSE

The Briggs property has an interesting history. Built as early as 1740, it was owned and occupied by Joshua Staples in 1759. The rear portion of the house may be the earliest portion; both sections of the house have a central-type chimney. In the rear portion, the large fireplace has been covered, but the wonderful old ceiling timbers have been exposed and give us a hint as to why the house has withstood 250 years.

Luther Robbins, a veteran of the Revolution, bought the house from Staples's widow when he returned from the war. It later passed to John Mellon, minister of the Congregational church from 1784 to 1805. It then became the property of the church. Reverend Calvin Chaddock lived here from 1806 to 1818 while serving the church. He also served as one of the first teachers at the Hanover Academy, which was then located close to the

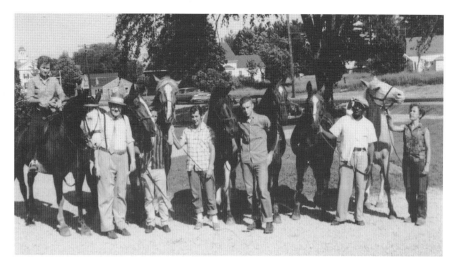

For the past century, the Briggs family has maintained stables at Hanover Center, giving the town a pastoral feeling unique to the region.

site of the Little League field across from the church on Center Street. (The academy was later moved to Four Corners and is still standing.) Reverend Seth Chapin followed Reverend Chaddock and served as minister from 1819 to 1824, residing in the house and also conducting a small private school for young ladies in a small building located in the front of his parsonage (long gone or moved).

Chapin, it is told, was a small, neat man and very particular. He laid out paths so that his students would not walk on his grass and posted a notice that read, "Ladies will please keep to the path." The first morning after the posting was a rainy one and puddles abounded in the path, but the young ladies splashed with glee through the water that had collected, following the directions posted by their teacher.

Church membership figures indicated a decline in religious interest, and at Chapin's departure, the church was lacking in financial support and was several years without a regular minister. In 1827, Reverend Ethan Smith was called to serve. He had nine children and filled the parsonage to overflowing. In 1833, Reverend Abel Duncan became pastor and stayed until 1854. At this time, the church's shareholders sold the house to Andrew Damon. He was owner of the house as it was pictured in the 1910 *History of Hanover*.

Damon kept a store, located on the Drinkwater Road (now Hanover Street), which he took over from his brother-in-law Perez Perry. Andrew Damon's daughter, Ella Damon, married J. Austin Briggs, and they

lived here followed by their son, Stanley A. Briggs, and his son, Richard Briggs. In the 1920s, Stanley Briggs, who was born and brought up in the old house, inherited the store. He had a delivery service from the store, as did many of the small businesses at that time. He delivered wood and ice as well.

In one of his notebooks, Charlie Gleason told the story of Briggs stopping frequently at a certain house to inquire if they needed ice. Being very, very, frugal, the answer was, "No, Mr. Briggs, we don't want ice today, because we are going to hang our meat, milk, and cheese down the well." This went on for quite some time, Briggs stopping and being told the same until one very hot day in August when the missus came running out, calling, "Mr. Briggs, Mr. Briggs, stop! We want some ice. The old man is dead!" Briggs is said to have replied, "Hang him down the well!" And slapping his horse, he drove on.

Stanley Briggs had loved horses since his boyhood and kept several for use in his delivery services. He enlarged his stable by boarding some of the horses belonging to Fred and Burt Phillips and gradually added others to his own. A fire in 1913 caused a setback—but ever resilient, this Yankee continued on—and in 1933, the Hanover Hunt and Riding Club was formed. Another even more disastrous fire ensued in 1934 when seventeen valued horses, frightened by the smoke, refused to leave their stalls and perished. It was a sad time for the family, but again, they continued on.

Before the town did any snow removal on the roads, it hired Stanley Briggs and his team to plow the sidewalks at the Four Corners. There were always children tagging along. Stanley's son, Richard, with a love of horses in his blood, became a lieutenant colonel in the U.S. Cavalry. When his father died in 1962, he took over the Riding Club and stable and lived in the old house. Briggs children from four generations have spent much of their time in the stables, and it continues in the family today. The little old store building has been made into a dwelling.

Generations of horse lovers have enjoyed quiet rides through the woodlands near Hanover Center because of Briggs Stables. The old house, the old and new barns, the corral and the trails all add a pastoral feel to our village we all enjoy.

JOHN CURTIS LOOKED INTO THE FUTURE AND LEFT A LEGACY

As one enters the John Curtis Library and ponders its past, one considers the role of the citizen today and that of the public library. John Curtis made a great gift to the town and its people. In a letter to the selectmen of the town in 1887, offering his collection of books, he wrote, "Born and reared in this town, I enjoyed the advantages of its public schools in my boyhood, and have never ceased to feel an interest in the welfare of its people....I desire to repay, in part, my obligation for my early educational training...with a purpose to afford better opportunities for coming generations of boys and girls of my native town."

John Curtis was the fifth generation to hold the name of John Curtis. Born in 1817 in the house at 702 Main Street built by his great-grandfather, he always considered Hanover his home. Jedediah Dwelley, in a speech at the dedication of the library in Curtis's name, said, "Though he sought his life work in the city of Boston...we would make a great mistake if we belittle the period of his life spent on the farm—for here his character was established." Curtis attended the district school, was a bright pupil and impressed a young teacher, who persuaded his parents to let their son go to Wesleyan Academy for one year. Returning, he attended Hanover Academy, walking both ways as was the custom in those days.

Upon leaving the academy, he sought his fortune in Boston and obtained a contract with a clothing firm, agreeing to stay with the company until twenty-one years of age for fifty dollars a year and his board. In Curtis's twenty-first year, the firm helped him set up his own business, and he made his fortune in the forty years that followed. He married and had one daughter and a busy life, but he never forgot his hometown and often visited his nephew, who lived in the ancestral homestead.

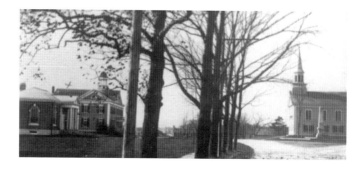

The John Curtis Free Library, at left, added to the convenience of Hanover Center when it was constructed in 1908.

An old lane, an old gate,
An old house by a tree,
A wild wood, a wild brook—
They will not let me be:
In boyhood I knew them,
And still they call to me.

John Curtis left more than his personal library to his hometown. He gave the land on which the Curtis School stood, and in his will—read after his death in 1900—he gave $15,000 for "the erection of a Public Library Building," the bequest payable upon the death of his daughter, Alice Marion Curtis. But during the year 1906, Miss Curtis waived her right, desiring to see the building constructed in her lifetime, and it was. Another Hanover citizen, Edmund Q. Sylvester, who was to give much to the town, was the architect for the new building.

In 1964, the growing Town of Hanover appropriated $175,000 to build a much-needed addition. The library is a focal point in the center of the town. Together with the town hall, the founding church, the old Stetson House and the Sylvester School it ties the bonds of the town together. It is the free public library for all Hanover people, and John Curtis saw the need.

Dwelley wrote of his friend, "Mr. Curtis enjoyed in his later years the leisure and delights which wealth properly used can give, and yet he lived the simple life. He was educated in the school of sympathy for the oppressed, in the school of service for others."

Here lived the men who gave us
The purpose that holds fast,
The dream that nerves endeavor,
The glory that shall last.
Here, strong as pines in winter
And free as ripening corn,
Our faith in fair ideals—
Our fathers' faith—was born.

Citizens of Hanover today strive to make our town a good place to live. Each has something to contribute to the future.

ST. MARY'S OF THE SACRED HEART

The first St. Mary's of the Sacred Heart was located on Broadway at the foot of Spring Street (which used to be called Purr Cat Lane). In old pictures, the landscape looks very open, and the church looks rather lonely.

After the Civil War and before the construction of the chapel, monthly and later weekly services for those of the Catholic faith were held in private homes of someone of that faith. One such home was that of Solomon Russell, who lived near the Rubber Mill at 180 Elm Street. Priests from St. Bridget's in Abington conducted the services. In 1879, Father William McQuaid of St. Bridget's purchased the site on Broadway on which to build a church for the people of the area. Many of the communicants were recent immigrants who worked in the factories or Irish girls who worked in the kitchens of the larger homes. This quaint little chapel was referred to as the "Chapel of Our Lady of the Sacred Heart." It was dedicated on June 25, 1882, and had an entry, small cupola and steeple and was built by Ranson and Higgins from plans made by J.H. Bearick. At first, it was serviced from Abington, but

The old St. Mary's Church stood at Broadway and Spring Street.

by 1883, the first pastor, Reverend John D. Tierney, had been appointed for the towns of Rockland and Hanover.

There was as influx of Polish and Lithuanian immigrants from 1900 to 1914, as well as Irish, Italians, Swedish, Germans, Russians and people of other nationalities. Many of these folk were of the Catholic faith, and the little church grew by leaps and bounds. By 1907, the parish had separated from the Rockland parish and included five towns: Hanover, Hanson, Pembroke, Halifax and Plympton. Father Charles Donahue served the church in 1912, and it was during his tenure that electricity was added to the church. He was the first pastor to live in Hanover, at 965 Broadway. He reported having some ghostly sightings in the house, and these reports were sensationalized by the local and Boston papers. Perhaps this is why his successors lived in Monponsett.

Reverend Patrick Crayton was appointed pastor in 1926, and it was during his tenure that three stained-glass windows over the entrance to the church were installed. In 1945, Archbishop Cushing separated the parishes of Monponsett and Hanover. Reverend Robert Hinchcliffe was appointed pastor of St. Mary's of the Sacred Heart, and with increased membership, the old Joshua Studley homestead and property was purchased on Hanover Street.

In 1953, a "new" St. Mary's was constructed at the north end of Spring Street on Hanover Street on the Studley property, and it was soon filled. The present rectory was built on the site of the old Joshua Studley house in the early 1960s. The old St. Mary's was used as a social hall and meeting place for religious and community activities such as the Knights of Columbus and the Boy Scouts. It was vacant for a while and then sold in 1984 to Mr. and Mrs. Gordon Baines, who gutted the interior and made it into a most attractive home for their family. It still retains the lines of the old chapel, minus the steeple, with the addition of an ell.

The Baineses held an open house for the community in 1985, and many reminisced about attending services in the old chapel. The second St. Mary's on Hanover Street became too small for its burgeoning population, and in 1991, a third St. Mary's was dedicated, constructed around the second church. It still retains the lines of a white New England church, and the parish is rightfully proud of its history and service to the community.

BURNING OF THE BEEHIVE

Here is the story of the "Beehive." The two-chimney colonial house was located on the north side of the Drinkwater Road (Hanover Street) opposite Spring Street, about where the tennis and basketball courts are now located. An old yucca plant that was planted there still remained as of the late 1990s.

The house was built in 1759, when the First Congregational Church entered into an agreement with Reverend Samuel Baldwin to be its second minister. The church agreed to build him a parsonage, and this was done at the expense of eighty pounds silver (English). It was built on the so-called "Common Lands," which Scituate had deeded to the Town of Hanover at the time of its incorporation in 1727. Reverend Baldwin had graduated from Harvard in 1752 and married Hannah Cushing, daughter of Judge John Cushing, in 1759. They raised a family of nine children here.

Under Reverend Baldwin's leadership, membership in the church increased, and a second, larger church was built in 1765. It was also used for town meetings, as was the first church. In 1853, historian John S. Barry wrote, "Mr. Baldwin early espoused the cause of America in the struggle

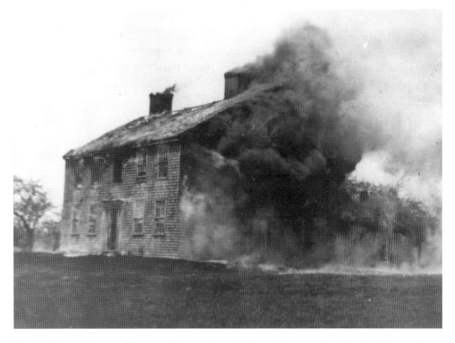

The Beehive, a home at Hanover Center, burned when photographer Charlie Gleason just happened to be down the street. He caught this scene and sold numerous copies to locals.

with Great Britain, and throughout the continuance of the war of the Revolution, took a deep and anxious interest in his country's success. He officiated as a Chaplain in the Army, and gave eloquent exhortations to his own flocks at home and to the minutemen of the town." The stress and strain of the Revolution made it impossible to keep up the payments of the clergyman's salary, and Baldwin was forced to resign in March 1779 after serving the church for more than twenty years. He died in 1784 and his wife in 1790. Their gravestone can be found in the Hanover Cemetery.

Mary Baldwin, daughter of Reverend Samuel and his wife, married Robert Salmond from Scotland in 1787, and they lived here for a time. In 1794, Robert Salmond conveyed to Caleb Marsh, a physician, one hundred acres and this house. Later, Seth Stetson lived here and served as postmaster, and so the post office was located in the old Baldwin house in the mid-1800s. In the late 1800s, several persons owned the house, and it fell into disrepair.

It was rented to several families at once. At one time, nineteen persons occupied the house, and because of their constant comings and goings, it was given the name the "Beehive." The Beehive burned in 1909, and Charlie Gleason, who left us so many pictures and anecdotes in his notebooks, took pictures of it as it burned. He said that he was selling goods to Mrs. Briggs just down the road when he heard the fire bell and raced up to the site. He had his trusty Brownie camera with him as usual and lost no time in recording the end of the Beehive. All that was left were the two large chimneys.

Gleason wrote, "It is to be regretted that such an historic house could not have been preserved." Not one to miss an opportunity, however, Gleason developed his film and sold the series of five pictures to those townspeople interested. He made enough to buy his wedding suit.

Hanover Cemetery Has Stories to Tell

The cemetery at Hanover Center is a beautiful and peaceful place at any season of the year. Many find it a safe and interesting place to walk. From time to time, the Hanover Historical Society sponsors a guided walk through the older part of the cemetery for its members and other interested folk. "How did it happen that you became the one to know the stories and lead the tour?" a reporter from the *Hanover Mariner* once asked me. I asked myself the same question.

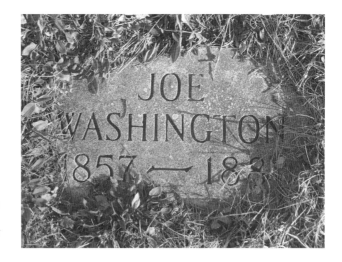

The story of Joe Washington is just one of the many tales to be told in the Hanover Cemetery.

In 1964, my husband and I bought the old Stockbridge House on Main Street. It was built in 1809, and I wanted to find out all I could about the house, who lived there and the town itself. And so began my journey and research to find out about the old houses in Hanover and the people who lived in them. These were the families who made the town of Hanover the fine place in which we live today. We joined the historical society and met many Hanover natives and longtime residents. They were most generous in sharing their knowledge.

Many of my old historical society friends lie peacefully in the cemetery today. People like the Bonney twins, who became my dearest friends and lived to be over one hundred; Aunt Fan Phillips; Dr. Donnell B. Young; Dr. Valentine Harrington; and others who encouraged me to inquire, research, photograph and write. I began to learn about the Curtis families on Curtis Street (now Main Street), the Baileys of the Revolution and of clock making fame, Tryphena Whiting and all the Whitings on Whiting Street, the Sylvester and the Salmond families at the Four Corners, the early ministers, doctors, the shipbuilders and common people with interesting names such as Snow and Bathshua Curtis, Melzar Hatch, Cindrilla Bass, Almerin and Chloe Josselyn, Zilpha Stetson and others.

Every family had at least one novel in it. When my youngest child entered first grade, I went back to teaching. I felt the children in Hanover should know about the heritage of their town, and so I began to expand and share my knowledge with them. One of the activities I developed after we had studied the history of the town was to take them on the tour of the cemetery. Their reaction was similar to mine. "Oh, there's John Curtis!" "Here is

Edmund Sylvester!" "Look! Colonel John Bailey!" It was like they were meeting old friends.

Now that I am retired, I walk with a friend almost every morning, and sometimes our route takes us through the cemetery. And that is how I always feel as we wander around. "Here's Reverend Benjamin Bass!" I almost cry when I read again the epitaph of Dr. Peter Hubbart (Hobart):

> *Thousands of journeys night and day*
> *I've traveled weary on the way*
> *To heal the sick, but now I'm gone*
> *A journey never to return.*

When we pass the plot of Reverend Cyrus Allen and his family, I remember reading in his daughter Fanny's diary her description of the funeral of her brother's wife, Lizzie, who died in childbirth just after their first anniversary. There are Dr. George Allen and Lizzie, and I weep for them. I would like to find the expertise and funds to clean the lichen and moss from the old slate stones so that more stories could be revealed. I would like to start a fund to replace the original stone of Joseph Washington, who is buried in the corner of the Church family plot. "Joseph Washington, born in North Carolina, Slave, died in Massachusetts, Free. 1857–1881." [This project has been completed.] I am not an expert on cemeteries, gravestones or cemetery lore, but I feel as if I know all these people and they have become my friends. The stories of their lives are part of the story of Hanover. And so, as a historian, a writer, a lover of Hanover and its people, past and present, I developed and led "A Tour of the Older Portion of Hanover Cemetery."

THE BUSINESS OF HANOVER

Hanover, A Town that Made Shoes

Most people know that Brockton was called "Shoe City, USA," but many of our newer residents don't realize that our town, Hanover, as well as Rockland, Abington and surrounding towns were important manufacturers of shoes as well.

The shoe industry had simple beginnings in our small town. At first, shoes for the family were made at home in a back room, woodshed or kitchen, where could be found a cobbler's bench, built to fit the need with drawers for tacks, holes for awls, knives and hammers. (Some of these relics are prized antiques today, polished up as coffee tables.) As time went on, men who were more skilled than their neighbors at cobbling began to set up little shops in their yards near the street, and the unskilled came for shoes and repairs. There were dozens of these little shoe shops along the roads on Main Street, Washington Street, Whiting Street and Broadway. Few remain. The Historical Commission saved one and had it torn down piece by piece and reassembled on the Stetson House property.

The 1850 Hanover census lists 228 shoemakers, and by 1860, the number had increased to 262. Many of these individuals are listed as cutters, stitchers and boot makers, which probably suggests they were beginning to work in the larger factories that had been established in Brockton, Rockland and North Abington and even in Hanover. The smaller shops closed, and the

Hanover once made shoes, first in small backyard shops like this one, then later in large factories.

workers went to the factories. Also, work was sent out from the large factories to the smaller shops to be finished. The Civil War made a great demand on the shoe manufacturers, and many cases of boots, made in Hanover, were sold to the U.S. government and worn by Union soldiers.

Business increased rapidly. Hanover's assessment for 1875 mentions fifty shops assessed anywhere from $20 to $200. By 1875, there were listed in Hanover several large shoe factories where men and some women were employed. At Mann's Corner in North Hanover by the present Baptist church, Samuel Buffum, George T. Damon, Sam Henderson, Caleb Mann and Henry Stoddard all had good-sized shoe factories. Some of these have been remodeled into homes today. Along Main Street in North Hanover were the shops of Rufus Crane, Marcus Mann and Joseph Studley. Those of Augustus Poole and the Studleys could be found on Whiting Street. The larger factory of George and Nathan Goodrich was located on Walnut Street. Killam and Turner had large shops at Assinippi and Charles and Elbridge Briggs on Washington Street at the top of so-called Briggs Hill. All these factories can be located on the 1879 map of Hanover.

About this time, there were so many shoes being shipped out (by the freight cars on the Hanover Branch Railroad) that the voters in North Hanover mustered their power at town meeting and voted to put a road through from Pleasant Street to Cedar Street, today called West Avenue. It was supposed to continue on through where the present high school is, across the Curtis fields and come out on Main Street near the Curtis School, but the farmers there blocked that move.

In the 1890s, the coming of the electric cars (or the trolleys) down from Rockland through North Hanover meant the end of the North Hanover factories. Nathan Goodrich, with the help of E.Y. Perry, closed his factory and built one by the railroad tracks in South Hanover. This shop was able to compete for some time. It was later sold to Shanley Shoe and later to the Clapp Rubber Company for the making of rubber heels. Dwelley and Simmons said that in 1910, "There is no one engaged in the manufacture of shoes in Hanover." Shortly before it was taken down, the Goodrich factory in South Hanover was being used as a hen house. An old house was moved from Weymouth (I think) and set on this site. It is hard for us who are not natives to Hanover to realize the factories that dotted the roads and streams in our town.

FIREWORKS

National Fireworks was located on the Drinkwater River, which was dammed early in the 1700s for early mills that began here. Factory Pond was formed by this dam. The historian John Barry said the name, Drinkwater, came from the tradition that when the first mill was erected, cold water, instead of liquor, was served as a beverage.

The Drinkwater Ironworks were founded about 1710, and the Barkers (no relation to my family) were known iron workers. Robert and Caleb Barker advertised in the *Weekly Advertiser* in 1754 that cast bells for meetinghouses and other usages were available for purchase here. L. Vernon Briggs, in his *History of Shipbuilding on North River*, says that during the American Revolution, cannons were cast here, and wrought-iron cannon balls were found here by George J.J. Clark when he became owner of the factory complex in 1899.

Early mills located on or near this location were a gristmill, sawmill, boxboard mill and a shingle mill, as well as forges that made bar iron and anchors up until the late 1800s. Charles Stetson was the owner of the property

George J.J. Clark became owner of the Drinkwater factory complex in 1899 and built a fireworks and munitions dynasty.

in the late 1800s and operated a machine manufacturing shop here until his death, at which time Clark entered the picture and began his National Fireworks Company. He eventually expanded his holdings to 200 fenced-in acres, about 150 adjoining acres, and 100 acres used for an airport and additional storage. Most of the land was located between King Street and Winter Street and Forge and Factory Ponds. Clark used the existing buildings and built many smaller buildings to manufacture and store his finished fireworks and, later, munitions.

With such incendiary products, it is not surprising that several terrible fires were associated with the business, but he built and rebuilt each time, trying always to make a dangerous workplace safer. The historical society has in its files several accounts of the 1905 explosion, which occurred in the laboratory and extended to at least ten smaller buildings out of the sixty in the complex at the National Fireworks property. Many workers were frightened, some hurt, but no one was killed or seriously injured. The blast was said to have been heard for twenty miles, and many of the neighbors in the Drinkwater section lost panes of glass, but the National Fireworks rose like a phoenix from such disasters.

One process developed by George J.J. Clark, certainly a local entrepreneur, was the way he found to make aluminum powder from the sawdust of aluminum comb manufacturers—using a dozen claw hammers attached to cams in a machine in such a way that they pounded the sawdust into a powder so fine that it floated in the air and was drawn by a fan though a pipe into a cloth bag in another building and used in special firecrackers. Charles "Aluminum" Briggs tended the machine, and you can imagine how he got his nickname. When powdered aluminum was made commercially, he moved on to making small firecrackers. He worked at the fireworks into his eighties.

During World War I, George Clark was called to Washington to solve a problem with tracer bullets, which were used to help the aviators make

sure their bullets were hitting the intended targets. Clark solved the problem and soon was asked how soon he could ship the first 100,000. When the bullets were put into production in West Hanover, National Fireworks was the only plant in the country to make them. Then powdered aluminum became scarce, so Clark got out the dozen carpenter's claw hammers and, using stick aluminum, crushed it to a powder. Clark was commended by the War Department for his efforts.

After World War I, the company again went back to making fireworks, with branch offices from Maine to Texas and an average payroll of 350. Then came World War II, and National Fireworks again became one of the largest munitions manufacturers in the country. It is hard to believe that in our little town of Hanover such a vital part of the war effort was conducted under tight security. Many folks who lived in Hanover at that time did their part for the war effort and worked at the Drinkwater plant.

At a meeting of the Hanover Historical Society held in 1980, Les Molyneaux, a local middle school teacher and chairman of the board of health, and Lawrence Slaney, a former fire chief and historical commission member, now deceased, conducted a meeting about the history of the National Fireworks. It was a very well attended and popular meeting, as many former employees attended and remembered those old days. Molyneaux, through his research, probably knows more about the history of the fireworks than anyone around.

After World War II, many changes, subdivisions and acquisitions brought about the dissolution of the old National Fireworks. Triangle Engineering now occupies the powerhouse building of the old Fireworks. Some of the land is now owned by the town under the umbrella of the Conservation Commission. Although the Environmental Protection Agency and Environmental Consultants have investigated and done removal action at the sites, there are still unanswered questions about disposal of the hazardous waste many years ago. (Clean-up efforts are underway as of 2017.)

CLARK FIELD

An airport in Hanover as late as 1958? Ah, yes, and at one time there were as many as fifty small planes kept there. W. Melvin Clark was the man who took his dream and "flew" with it. I interviewed Clark in 1977 when making a film for the 250th anniversary of our town. I got out the old tape

as I was writing this essay, and Melvin Clark's New England twang came over loud and clear.

Son of George J.J. Clark, entrepreneur and founder of the National Fireworks, Melvin had a creative and courageous spirit. Born in 1902, he was intrigued with the early airplane and, as a young man, hung around the Dennison Airport in Quincy. He bought what was left of an old Kittyhawk and brought it to his home on Winter Street, where he tinkered with it and put it together. In those days, the body and wings were covered with an Irish linen–type of canvas. This was covered with what was called "airplane dope," which caused the canvas to shrink tightly around the wing and body forms. Ten to twelve coats were applied until the surface was as tough as metal.

Clark told the story about a day in 1927. He was running the plane up and down the field in back of his house and then he just kind of "took off." There was hardly enough room to land back on the field, but somehow he did. Then he called the Dennison Airport and told them what he had done, and said, "But I don't have a license." "Why don't you fly over and get it?"

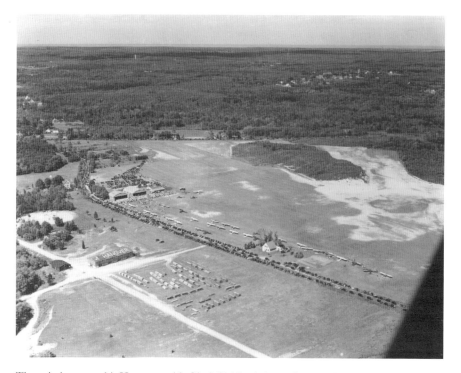

The aviation craze hit Hanover, with Clark Field existing as late as 1958.

was the teasing reply. "I'll come right over," said Melvin. And fly over he did. W. Melvin Clark received license number 17,540.

The airport was fashioned out of Melvin Clark's backyard, field and adjoining lands belonging to the Holbrooks, Robinsons and Greens. A high tension wire had to be moved, and even more difficult in those days (1929) was the leveling off of two hills and removal of many stones. There was a line of elms on Winter Street cut down and an orchard of apple trees removed to make room for low-flying planes and three runways.

The airport was located in the triangle between Winter, Myrtle and Center Streets. Today, streets with the names of King Phillip Lane, Massasoit Lane, Samoset Drive, Pocahontas Lane and the like crisscross the old runways. I wonder what the homeowners think when they dig down and hit some of the old tarmac.

When the airport began, there was one plane, one hangar and thirty-five acres, but it expanded as more land was needed, and East Coast Airways, as it was officially called, housed private planes from Hanover, Marshfield, Rockland and Abington and was listed as a commercial airport. Most people around here called it Clark's Airport, and it was a thrill to go down to West Hanover and take a Sunday sightseeing ride.

Clark told of being the first air policeman in Hanover. It was his job on summer Sundays to keep sightseeing planes away from a nudist camp on the North River. He thought it was quite a joke, because it was pretty hard to control, until the federal aviation inspector told him to "just take their number, and I'll take their license." Then there was no further need for an air policeman.

Clark became the first airmail pilot in Hanover, carrying mail from Hanover to Brockton to Boston. He had his airmail pilot certificate dated May 19, 1938, a one-time ceremonial event for Air Mail Week. Melvin Clark never lost his love of flying and adventure. He spoke about flying to the World's Fair in Chicago, and what a thrill it was to find his way there. He made three different trips across the country to California, Texas and Seattle, Washington. He was the first person to land a private plane in his father's birthplace, Prince Edward Island. He spoke of scaring the cows down to one end of the field so he could land at the other end.

During World War II, he sold the airport land to his father, who needed the space to store magnesium powder and other materials used in the manufacture of the munitions made at the National Fireworks. After the war, Melvin Clark bought the land back from his father, and the airport continued for ten more years. With the coming of the larger planes and air

traffic from South Weymouth, Clark didn't enjoy competing for airspace. Two large planes, one in trouble and one mistaking Hanover for South Weymouth, landed dangerously on the short runways. One was taken apart and towed to Otis Airfield on Cape Cod because it couldn't take off on the runway.

When the airport had closed and the land sold, Clark took his plane and one hangar and made a deal with the owner of the Plymouth airport. He could keep his plane there in his hangar, and when he sold his plane, he would leave the hangar.

Horse and wagon, stagecoach, train, trolley, airplane—in Hanover today, the automobile is king. If you have any old pictures of earlier Hanover days, the Hanover Historical Society would be interested in borrowing and copying them for their files. Bring them to the Stetson House. Last year becomes tomorrow's history. Help us preserve it.

EARLY INDUSTRIES AT LUDDAM'S FORD

The Indian Head River, with its headwaters in Hanover, empties into the North River just below Luddam's Ford. It is fed by the Drinkwater River and numerous small streams that course through the town. Early on, it served as a pathway for Indian canoes and provided the Native Americans with fish such as shad, alewives, trout, perch and pickerel, among others. The area has been called Luddam's Ford for many years in recognition of one James Luddam from Weymouth who served as a guide for Governor John Winthrop of the Massachusetts Bay Colony, who was on his way to a meeting with Governor Bradford in Plymouth in 1632. Legend has it that Luddam carried Winthrop on his back as they forded the river at a rocky spot just below the present bridge.

As settlers moved into the area that was to become Hanover, they saw the river as a source of water power for their future mills. Early on, a dam was constructed here on the Indian Head River at Luddam's Ford. By 1693, Joseph Curtis, Josiah Palmer and others entered into an agreement "for erecting a saw mill on that part of the Indian Head River a little above the cartway" (Elm Street). By 1704, an ironworks had been constructed. Thomas Bardin, an immigrant from Wales, was an early pioneer in the industry of turning bog iron into iron utensils. Later names involved in this forge were Wanton, Randall, Barstow and Josselyn.

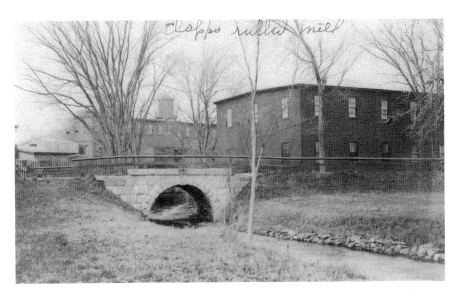

Today's Luddam's Ford is a place of serenity and placidity. For about two centuries, it was a place of big business, as seen here at Clapp's Rubber Mill.

By 1720, Josselyn of "Old Forge" held a major portion of the shares and did so until 1790. In 1791, the Curtis family, Lemuel, Ruben and Consider, became longtime owners. Later, George Curtis and Lemuel Dwelley took over. Curtis Iron Works, as it was known, made anchors ranging from one thousand to ten thousand pounds, and during the American Revolution, it made many anchors for the government. Later, the anchors for the ship *Constitution* were forged here. A gristmill was operating here in 1791, and a sawmill was still in use in 1873. In 1839, a carding mill that had been built upstream at the junction of Rocky Run Brook was moved to this site as well.

In 1873, the iron forge property was sold to Eugene Clapp, whose business was to grind products that contained rubber for reuse. He was a pioneer in the recycling industry. However, the waste was dumped in the riverside swamps and still remains today, somewhat overgrown, as an early trampoline (an early polluter). The "old forge" building burned in 1881, and Clapp constructed a much larger mill and later built repeated additions and buildings on both sides of the river. The rubber mill was the last active business to operate here. At times, over four hundred men were employed.

A terrible fire occurred in 1923. The business was rebuilt, but then the Depression hit and the company went into receivership. At the time of its closing, it was the largest rubber reclaiming mill of its kind in the country and covered eighteen acres along the Indian Head River. On the

receivership inventory were listed thirty-five buildings in the factory area, as well as numerous other pieces of real estate (worker's homes and such) in the adjacent area of Water Street and Clapp Road. The Grossman company owned the property for some time, and then it was purchased by the town in the 1930s through the efforts of then Selectman Fred Nagle.

The Hanover Branch Railroad crossed Elm Street just above 251 Elm at Curtis Crossing and became an important part in the development of the industries at this site. And when the businesses failed, the need for the railroad diminished. All the factory buildings are now gone. A fish ladder was constructed by the state to aid the migrating fish in reaching their spawning grounds farther upriver.

The Towns of Hanover and Pembroke now own the land on each side of the river as conservation land. The river flows cleaner, the shad and herring have returned and youngsters and oldsters fish and hike and picnic. In the 1970s, the Tri-town Rotary Club worked to make the area more accessible, but members were discouraged by vandalism. Today, it is great to be present at this rededicated historic place.

Project Dale

There is a peaceful spot in Hanover referred to by many as "Project Dale." It is located in the beautiful valley (dale) alongside the Indian Head River. What the "project" was I have not been able to determine, but the name goes back to at least until 1853, when J.S. Barry, in his *History of Hanover*, said, "[A]t a place called 'Project Dale' stands the tack factory of Mr. Edward Y. Perry, moved to this spot by Mr. Charles Dyer about the year 1830." Barry notes "the location of these works is very pleasant, especially in the summer season, being in a quiet dale, surrounded by hills, clothed with evergreen, and deciduous trees."

Earlier, there was located on the same site an old dam, a gristmill and a carding mill. We find a reference to the term "Project Dale" from papers that were in the possession of Charles Dyer that James Torrey had a fulling mill at this spot in 1737, at which date the place was called "Project Dale." Dr. L. Vernon Briggs, in his *History of Shipbuilding on North River*, devoted several pages to the manufacturing that took place "along the beautiful Indian Head River as it flows over its shallow course beside the railroad and the delightful drive known as Project Dale." He tells us that "there was

formerly a bridge over the Indian Head at this point, but it disappeared many years ago."

Perhaps this is where the term "piers point," which I recently heard in describing the place, came from. Briggs described the history of the mill site as it passed from James Torrey to Nathaniel Josselyn, "Josselyn's Corn Mill" to Joseph Stetson, thence to Lemuel Curtis, Nathaniel Curtis and Aaron Hobart. About this time, the dam was raised four or five feet.

Helen Whiting gave a description of the manufacturing that took place at the site. Jesse Reed, who had come to Hanover about 1812, invented a "machine for making and heading tacks in one operation, which made it possible to produce 60,000 tacks per day....He built a dam and put up a grist mill and nail factory at Rocky Run," a short distance above Project Dale. In 1830, Charles Dyer moved the tack factory down the river to the Project Dale site and conducted the works for ten years as an agent for Elihu Hobart. Of course, the illustrious E.Y. Perry got into the act, and in 1850, he took charge of the works until he moved upstream to the Barstow works, which later became the Phillips factory in South Hanover.

Perry was the founder of the Hanover Branch Railroad and was always interested in developing business that would use the line. The tracks followed the Indian Head River from South Hanover to the station near

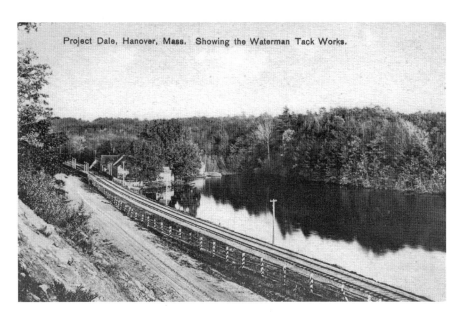

The old railroad bed that ran alongside the Indian Head River, right past Project Dale, is now a walking trail.

the Four Corners. Riders on the line always looked forward to the ride on the train beside the river and the scenic view of Project Dale. Since the tracks have been taken up, this path forms the main route of the Indian Head Greenway.

It is a pleasant walk along the river, and one experiences the pastoral atmosphere of Project Dale. Dr. Briggs continued with the following description: "The location…is very picturesque, being on the edge of a placid pond, which during the summer sunsets is a perfect mirror. It is surrounded by hills, thickly grown with foliage and has a beautiful fall of water over the dam most of the year."

George Curtis was the owner of the factory at Project Dale in 1870 when he sold to Lemuel Waterman, Rudolphus Waterman and George Clapp. When known as the R.C. Waterman Company, an exceptionally fine line of tacks and nails were made here, and many shoe repair shops, especially in New York and Philadelphia, refused to use other than Waterman's tacks. The sons and grandsons of the aforementioned Charles Dyer were known as highly skilled tackmakers for the Waterman Tackworks.

In February 1886, there was an uncommonly heavy fall of rain that took out upper mills on the Indian Head. At Project Dale, the water poured into the factory, and the dam was partially carried away—as well as the underpinnings of the factory—and some of the tracks were damaged and the train halted for a time. Later storms did damage to the dam, but hurricanes in 1938 and 1954 really took the dam and pond out so that we can no longer see the peaceful pond referred to in earlier writings.

Different businesses have occupied the site since the Waterman Tack Factory went out of business. Evidence of a fire about 1927 can be found today. The Depression followed. After World War II, James Sylvester ran a company called Silful Art Glass. I wish someone who worked there could tell me more about it. The Norman Robbins Window Company operated here for a while. In the late 1960s, thirty-five people were employed making bataka bats. For many years from 1974 forward, William Barr of Hingham ran the Universal Tipping Company and proved to be a good neighbor. I may have missed a few since Waterman's Tack Factory.

The red house located opposite the mill at 361 Water Street goes back to about 1726 and Nathaniel Josselyn, who had secured early mill rights. It was enlarged and the house and mill rights sold to many of those mentioned earlier. Most of the subsequent occupants were in some way connected with the mills. Charles Dyer, who was Hobart's agent until 1839, lived in the

house a number of years, as did his son until his marriage in 1874. For a long time, it was rented. It the 1940s, a family by the name of Foley owned it. From the 1960s on, it was the home of the Currier family.

Project Dale is still a place of refreshment. Wildflowers and ferns abound along the shores of the winding Indian Head River and take us back through the many lives that have been influenced by the place.

Gardening and Floriculture in Old Hanover

The Beal Greenhouses and Flower shop existed in the Four Corners from about 1900 to 1957. The flower shop was between the Episcopal church rectory and the house of Captain John Cushing, later J.W. Beal. Behind the flower shop were the greenhouses, which stood about where the shops at 272 Columbia Road are now located. Here were raised a variety of flowers for the retail trade but more importantly for the wholesale trade, as they could easily be shipped by train into Boston.

Carnations were the specialty of the the Beal flower business. Mr. McCrae was in charge of the greenhouses. When the railroad left the Four Corners, the greenhouses were sold and taken down. Listed in the business directory of 1902 as a florist and dealer in coal in West Hanover was Alpheus Packard. Packard's greenhouse closed about 1912 due to his failing health. His specialty was gladiolus, and his fields and business were also located near the railroad for convenient shipping.

Also listed as a nurseryman and florist in an early 1900 directory was George Sylvester, who lived at 839 Broadway. Remnants of his old nursery are still evident. The farmer chose his stock of apple and pear trees for his orchard carefully and learned how to graft them to the sturdy wild stock. Grapevines were studied carefully to get the best grapes. Dr. Donnell B. Young used to tell that his family had one of the first Concord grapevines in this area. For many years, his daughter made wonderful grape jelly from these vines.

Of course, going back to the beginnings of the town, almost all the early settlers were farmers, for their very existence depended upon the food they raised. The colonial housewife had her kitchen herb garden for medicine, cooking and pleasure, in that order. She hunted the wild plants in the spring: wild asparagus, fiddlehead fern, dandelions and the like. All spring greens were considered a good tonic. Even the Victorian woman who enjoyed a

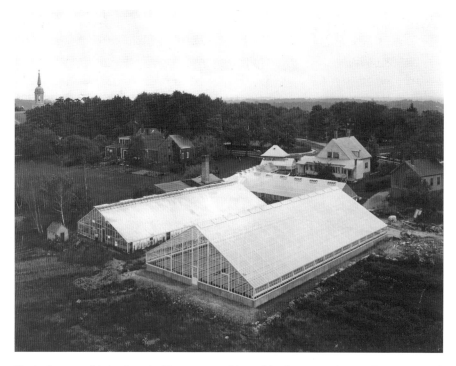

Floriculture was big business in Hanover, as evidenced by these greenhouses that once stood where the Tedeschi's Plaza is today on Washington Street.

spring walk in the woods would wait for the wildflowers as they appeared and note them in her diary.

During the late 1800s, interest in bedding out began to grow, and flower gardening took on a new dimension. Although photographs about this time show that the land was much more open and bare because the available wood had been cut for cooking, heat and building, the area near the houses, large and small, began to be softened by flowers and shrubs. In 1927, Olive Beal in the Four Corners invited a group of her friends into her home and gardens, and the Hanover Garden Club was formed. It met in members' homes and gardens during the growing season but never in the winter, because it was harder to get about then. The Hanover Garden Club today maintains the same meeting schedule.

One of the most interesting projects of that early club was sending garden produce into Boston. Each week, members would bring their garden flowers, fruits and vegetables to the home of Mrs. William Bates at Four Corners, where they were packed in hampers and then taken by auto to the station

at Greenbush in Scituate. The train left at 6:00 a.m., and that meant rising very early. Once in Boston, the hampers were distributed to the needy by various agencies. This project continued until 1957, when the train service to Greenbush was discontinued.

Today, interest in landscaping and gardening has become very important to many homeowners. Membership in garden clubs has increased, and Hanover now has two garden clubs. The Walnut Hill Garden Club has joined the Hanover Garden Club in planting a period herb garden at the Stetson House and in planting and maintaining traffic islands throughout the town, which all who drive through our town appreciate. We who are interested in historic preservation are not only interested in preserving brick and mortar but in preserving our wetlands, wildflowers and wildlife and living in harmony with them as well.

BROOKS' STORE IN NORTH HANOVER

From its founding, the town of Hanover, as most country towns in this area, was made up of different villages. Each village had its own school, a store and often a particular industry or factory. Most had a church, and Four Corners, South Hanover and West Hanover each had a railroad terminal. The villages were quite separate, and it was not unusual that the only time men and women from the different villages met was at town meeting.

Each village had its leaders and its characters. In North Hanover, the Brooks family was a family everyone knew and looked up to. Samuel Brooks, born in Hanover in 1742, was a descendant of William, who arrived in New England in 1635. Samuel lived in a house on a cart path off the present Webster Street in North Hanover. He died at age eighty-seven in 1829. Many of his descendants built their homes and raised their families in North Hanover. At the incorporation of the Baptist church, five of the twenty-four were Brooks. The Baptist church was erected in 1812 on Main Street next to land on which Brooks' Store was built.

Brooks' Store was founded in 1854 by John Brooks, his son John S. Brooks, William Church and George Damon. John S. Brooks was elected agent, set up his shoemaker's bench in the back of the store and eventually bought out the other stockholders. He and his brother Thomas operated the store until the early 1900s. John S. Brooks had a son, John Flavell Brooks, a very bright boy who graduated from the Massachusetts

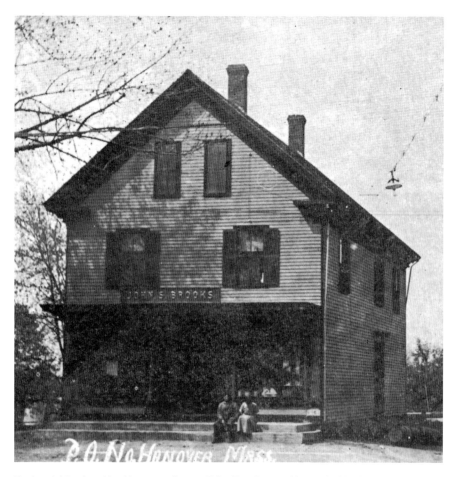

Each neighborhood had its general store. John Brooks ran this one in North Hanover.

Institute of Technology in 1896. John F. came home to Hanover to help out his father until he died in 1909 and then continued to run the store until his own death.

The first John S. Brooks was postmaster for twenty years; his son, John F., succeeded him. For seven years, John F. served as town clerk and treasurer of the town. He was superintendent of the Baptist Church Sunday School and each week compiled the weekly calendar and sang in the church choir. As general storekeeper, he found an amusing way to advertise his goods. He composed little rhymes, sent them out on postcards and advertised in the local paper:

"Wingold Flour" by John F. Brooks

The girls around are going wild,
They always have been very mild.
Their bread they say is nice and white
And rises up so very light,
They talk about it by the hour,
They make it now of Wingold Flour.

The religious influence of four generations was apparent in the atmosphere of the store. Honesty was first. "I owe you eight cents," said a clerk. "What for?" "Don't you remember? A few days ago you didn't wait for your change." Tobacco was screened from view by a pile of biscuit tins. No cigarettes. The Brooks brothers, sons of the postmaster, were valued baseball players, but when it was decided to play Sunday games, the Brooks boys didn't play. They worked out with the team on weekdays, but good Baptists that they were, they didn't play ball on Sunday.

Another poem from "Tales from the Village Store":

"A Short Winter"

Some men one day were talking together
As usual about the weather,
The drought, the crops, the early frost,
And all the things that they had lost.
And of the many things they'd need
To keep them warm, the stock to feed.
One said, "The Summer now is gone,
A long hard Winter is coming on."
An old man then had his say,
"Young men just sign a note today
That's due in Spring, you'll change your thought,
You'll think the Winter is very short."

(Poem given with others in his own handwriting by John F. Brooks to Alice Bonney)

John F. Brooks wrote over one hundred poems about his store, people he knew, his philosophy, his family. He gave a copy of his collection to each

of his grandchildren—a treasure. Above all, he was a family man. Upon the death of John F. Brooks in 1945, his son John S. Brooks continued to run the store in much the same manner as his father. With the coming of supermarkets and the decline of "the village," the store closed in the late 1960s.

JOSSELYN'S STORE, WEST HANOVER

Years ago, the villages of Hanover were more distinct, each village having its own district school, post office, fire department and general store. The villages were somewhat competitive but always ready to help one another when the chips were down. The Josselyn and White General Store in West Hanover conducted a regular grocery route, taking orders from the housewives, and made deliveries on regular days by wagon. Irving I. Josselyn joined his father, Lewis Josselyn, and Mr. White in the business.

The West Hanover store had its beginnings about 1857 when Horatio B. Magoun, who peddled groceries from a cart, set down roots and began a small business in a cottage house with attached barn. Later, it was enlarged and moved and the original barn separated from the store and then moved again and made into a two-family house (1448–50 Hanover Street).

The timing was right. The reason Magoun expanded was for the storage of molasses, flour and sugar, as the Civil War was imminent. Of course, the Hanover Branch Railroad was operating by 1868, and the station was right across the street. This was convenient for shipments of supplies for the store. Magoun was appointed postmaster of West Hanover by President Lincoln in 1861. The post office was basically a few boxes at the right side of the long, narrow store. It was connected to the store until about 1908, when a separate addition was made to hold the post office. Magoun served as postmaster until 1901, when he was succeeded by his son-in-law William H. White.

Others who held an interest in the store over the years were Magoun, Morton V. Bonney, William H. White, Alpheus Packard and his son Edmund, the aforementioned Lewis Josselyn and son Irving and John F. Chase.

I will focus the operation of the store on the Josselyn family, as Esther Josselyn, the source of most of my information, was the granddaughter of Lewis Josselyn, sometimes referred to as the "grand old man of Hanover," who lived to be 101. Josselyn entered the business in 1880 as an employee of

M.V. Bonney, and in 1890, he and Alpheus and Edmund Packard purchased the business, then called Josselyn & Packard. Later, Josselyn took on White as a partner. The partnership didn't last too long, as White was more interested in music and playing in bands.

In 1904, Lewis Josselyn changed the name to L. Josselyn and Son. The son was Irving, who took over the business in 1916, but the name remained unchanged. It continued in the Josselyn family until 1946 and finally closed as a general store in 1955. In the words of Esther Josselyn, "For nearly a century this business of the old-fashioned type store continued carrying a good assortment of articles for the farmer, mechanic and housewife."

Following are some of Miss Josselyn's memories:

> *Large head of cheese and boxes of crackers…cookies in bulk…prunes in bulk…the filling of the candy dishes in the glass-enclosed counter… smoked herring in bulk…slightly salted herring speared on sticks that always smelled…the horse whips hanging on the rack in the front window…the old stove in the center of the store…tripe sold in bulk, as well as lard and butter in their firkins…the molasses barrel in the cellar…cases of canned goods in the cellar…spices all stored in the small drawers on the shelves…hardware in the back, and the nails of all sizes in their bins…window glass of varying sizes all stocked up…patent medicines, men's underwear and work pants, ladies and men's hose… thread of all colors, as well as pins and neckties…rows and rows of soap and soap powders all stacked up.*

There was some type of general store in each village. Some had a delivery service similar to that of Josselyn and White; Brooks' Store in North Hanover and Killam's in Assinippi made such deliveries. Probably others did as well, and of course, Charlie Gleason had his peddler wagon until 1938. The days of the general store and the delivery wagon are gone, and the villages blend together. All have their stories to tell and are part of our rich heritage.

SOME HANOVER PEOPLE YOU SHOULD KNOW

THE VILLAGE BLACKSMITH

Under a spreading chestnut-tree
The village smithy stands;
The smith, a mighty man is he
With large and sinewy hands;
And the muscles of his brawny arms
Are strong as iron bands…

So begins the well-known poem written by Henry Wadsworth Longfellow in 1840. Blacksmithing was a craft that had its beginnings 2,500 years ago. In the early days of life in America, each village had its blacksmith. They were an important part of the community. The blacksmith, so called because he worked with black metal (iron), worked at his forge, using a hot-fired pit, bellows, hammer, chisel and tongs. He pounded out (forged) the red-hot iron on his anvil into useful implements for the farmer, shipbuilder or housewife. He sometimes filled the roles of farrier, wheelwright, veterinary surgeon, doctor, even dentist if no other help was available.

About the oldest manufacturing of any kind in Hanover was that of iron working. At first, the ore was found in the nearby swamps and ponds, the pellets raked out, melted down and used by the blacksmith and the larger forges. Those of us who have lived in Hanover before the filtration plant was in operation remember the rust-colored water that came from the

Charlie Gleason, who developed a habit of adding his bike to his photos, took this image of a former blacksmith shop in South Hanover, long after its halcyon days.

deposits of iron still in our ground. "Iron Mine Brook" in South Hanover deserved its name.

Matthew Stetson, grandson of Cornet Robert Stetson, was granted a part of the so-called "common land" in the Four Corners area, then a part of Scituate before 1727. Here he built his house (233 Washington Street). He was probably the new town's first blacksmith. His shop stood near the corner about where Mary Lou's coffee shop is now located (211 Washington Street). A town record of February 1734 speaks of laying out a part of Broadway "beginning at Matthew Stetson's shop." Matthew Stetson also served as schoolmaster during the winter terms as well as practicing his blacksmith trade. About 1742, he sold his house and shop to Malitiah Dillingham, also a blacksmith, and continued working in the shop.

Being located near the shipyards, it no doubt did much business making chains and other findings for the ships. Malitiah Dillingham was followed in the blacksmith trade by his son, Joshua. About 1802, the house was bought and occupied by Joseph Eells, whose father had a blacksmith shop on the opposite corner. Joseph Eells and his brother, Robert, continued in the blacksmithing trade in the shop, which was located in back of where Lorraine's Cake Supply is now (148 Broadway).

Following are examples taken from their account book that reveal the type of work and prices of the trade. The spelling is original to the account book.

Seth Chapin [minister of Congregational Church]
To setting one shoe on your hors-10 cents. To mending your chaise [carriage] *25 cents. To fitting a pare of sills to your slay $1.33—*
Elisha Bass To 12 ribbets on your gigg—[He means rivets]—
Rev. Wolcott [rector of St. Andrew's] *To shoe your hors all round new $1.17. To setting one oxe shoe 12 cents.*

Warren Wright (born 1809), great-grandfather of Betsy Sylvester Robinson, kept a shop in the same vicinity near his home at 176 Washington Street. His portrait is displayed in the Stetson House. Later, Jim Jones plied his trade in this area for over forty years and certainly looked like Longfellow's "village blacksmith." Charlie Gleason said, "Jim Jones was the last blacksmith in these parts equipped to shoe oxen." Gleason also noted that Jones was the victim of Fourth of July tricks and would find "the village boys had often hoisted a wagon wheel up in a tall tree for Mr. Jones to retrieve." E.Y Perry moved part of the Eells's shop to around 215 Broadway near the present fire station. Tom Turner used it for making carriages. A fire destroyed the building, and in 1896, a new shop was built. Al Morrill was the blacksmith, later Ellie Curtis. According to Charlie Gleason, this "blacksmith shop was a small hall for social events, but was rather smelly. People were not so particular of odors some years ago."

Charlie Stearns was another blacksmith associated with this location. This shop later became Percy Bonney's woodworking and repairing business, "Joseph's" (the clothier), "Hit or Miss," a mattress store, and a real estate office, but has since been torn down. In South Hanover, Fred White's blacksmith shop was located near the location of the fire station. In West Hanover, on Pleasant Street opposite Elias's Mill was located the wheelwright and blacksmith shop for that village. In Assinippi, Frank Alger's blacksmith shop could be found in the triangle opposite the cemetery. With the coming of the automobile, the decline of the use of horse and carriage and the rise of modern manufacturing, the skills of the blacksmith were no longer in demand. Many shops became garages and gas stations. The blacksmith became mainly a farrier, a shoer of horses. Now most farriers carry their tools in their trucks and travel to their appointments. The village blacksmith shop is gone, a remnant of the past.

HANOVER'S GRAND OLD MAN

Lewis Josselyn was referred to by many as "Hanover's Grand Old Man." He had a long and interesting life. Born in Hanover on August 15, 1842, he was one of thirteen children. His father built a house on School Street, which Lewis later bought. He wrote an account of his life and described his adventures during the Civil War, his travels to the West, his experiences in business as a storekeeper and other events in his life.

He told of attending the district school in South Hanover and then going into shoemaking and farming with his father. In his personal narrative, he related that "at the age of 14 he joined the Sons of Temperance and never indulged in intoxicants." Lewis Josselyn noted that in 1862 he answered Lincoln's call for volunteers and, along with twenty-two other Hanover men, set out to preserve the Union. (At the outset of the war, available men between the ages of eighteen and forty-five were called, and a total of 169 Hanover men enlisted.)

Twenty-year-old Lewis Josselyn saw parts of the country he had learned about in school but never expected to see. He went to the Chesapeake Bay, to the Hampton Roads, around Cape Hatteras in a storm. He became sick with typhoid in Carrolton, Louisiana, later joining up again with his regiment at Baton Rouge. He was sent on to Cheeneyville, re-crossing the Mississippi to Fort Hudson. He recounted, "[T]hat was one of the hardest days of my life. On the 27th of May we made our first assault on the fort and were repulsed—losing our Colonel and a good many men. On the 14th of June we made our second assault and were again repulsed with a great loss of men. On July 7, 1863 Fort Hudson surrendered to us." In 1864, his regiment was sent up the Red River to fight at Cane River, where they defeated the Rebels.

He recalled how he and Atkins Brown (who was later killed in the Shenandoah Valley) had an exciting time. They became separated from the rest of the company, and suddenly they came upon a Texan soldier. Both were surprised. "I commanded him to surrender. He seeing us at the same instant, stopped, turned and retreated. I fired, but failed to bring him down which I was always glad I did."

Josselyn went on to Mensura Plains, where he saw "the greatest military display of my life." He later witnessed the first ironclad gunboat as "it passed through a breach made in the dam, going nearly all under water." From there, he was sent to Washington, to the Shenandoah Valley and Georgia, while General Sherman marched from Savannah. On June 30, 1865, he

Lewis Josselyn (*center*) was Hanover's last living Civil War veteran, known as the town's "Grand Old Man."

received the "welcome news" to start for home. "How pleased we were to get home no one can tell—only those who have been away for three years." In 1871, Lewis Josselyn married Ella Sampson, and they had four children, one of whom, a son, died young. After the birth of their fourth child, Irving, in December of 1877, Ella contracted scarlet fever and died nine days later. The young Lewis took his two daughters home to his mother, and his brother and his wife raised the baby, Irving, until his marriage. In 1886, Josselyn, still wanting to see more of the country, took an excursion to California, about which he wrote of the sights he saw as he traveled across the United States.

In 1889, Josselyn married a second time, Mabel Corlew, and they had eight children. Their last child, Russell, was born in 1915, when Josselyn was seventy-three. After the war, Lewis Josselyn worked in the shoe industry for a few years and then in 1880 went to work for Morton Bonney in his store. Later, he purchased the store with Alpheus and Edmund Packard,

and the store in West Hanover at the corner of Circuit and Hanover Street became Josselyn and Packard. Later still, he joined with White, and the name changed to Josselyn and White. In 1904, the name again changed to L. Josselyn and Son when he took his son Irving into the business.

In 1915, he left the business in the capable hands of his son and retired to farming. But he certainly didn't retire from life. He enjoyed attending Grand Army of the Republic (GAR) functions near and far. He always got in his uniform and marched in the Memorial Day parade. Charlie Gleason, who recorded the Grand Old Man in photos, described him in 1940 at age ninety-eight as "still going strong. Spry and strong, with no aches or pains, he bids fair to reach the century mark. He has a good-sized garden each year and takes delight working it. Until a year or two ago he walked down to the airport every day and invited the men to take him up for a ride....His mind is still keen and he steps off briskly as a man of thirty."

Maybe his stand on temperance can account for his energy and longevity. His grandson Wendell Henderson recounted a family story that during the war when Josselyn was offered a drink of liquor, he used it to rub on his sore feet. Lewis Josselyn died on February 15, 1944, when he was 101 and 6 months.

CHARLIE'S WAGON

Let me tell you a little about Charlie Gleason and his peddler's wagon: Charles Gleason was born in 1880 in Barnett, Vermont, and came to Hanover in 1904. He found room and board at Joe Frank Stetson's place near the Four Corners (and later married Mrs. Stetson's niece, Olive Prouty, from Rockland). Charlie bought a wagon third hand (it was new in 1880) from Judge George Kelly's brother in Rockland, and for fifty dollars he bought a horse from Dan O'Brien. Charlie said it was the best horse of the twelve he owned. Nancy Hanks was her name, and he said in those days (1904) there was not a paved road in Hanover or any surrounding town. "I could throw down the reins in Duxbury, curl up on the seat, go to sleep, and the horse would take me right home."

Once, however, Charlie left Nancy drinking at the old pump by the newly built fire station near the Four Corners, and when he came out, the horse and cart were gone. He supposed they had gone home, but they were not there. He got a lantern and traced the horse's foot and wheel marks and

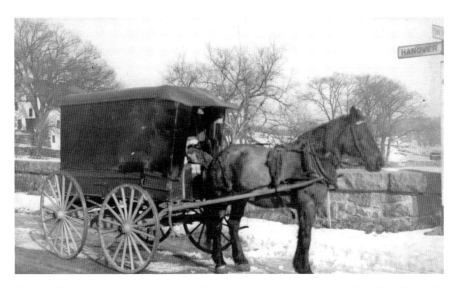

Charlie Gleason's wagon carried everything a homeowner needed, including himself, a jack of all trades available for hire.

found that the horse had evidently mistaken the spur railroad track for Joe's road to the barn and had ended up in the coal shed at the terminal.

For over thirty-five years, Charlie Gleason's peddler's wagon traversed the roads of Hanover, Norwell, Pembroke, Marshfield and Duxbury selling needles, dishes, skirts, petticoats, stockings and even corsets, among other things. One of his customers, Lillian Whitaker of Pembroke, wrote, "I have a red table cloth that I prize…[I]t is a relic of the day when a traveling dry goods cart used to come every so often to our door. I love this tablecloth, purchased from Mr. G--. Despite many washings its colors are still bright. The driver was a friend to his customers and often carried messages and packages from mother to me or vice versa."

Charlie Gleason was a friendly and unusual man. He was more than a peddler; he served as selectman, assessor, and overseer of the poor for a period of thirteen years. He knew just about everybody in town. Charlie was also an amateur photographer. Shortly after he arrived in Hanover, Charlie acquired a Brownie box camera and learned to develop his own negatives. He began the first of some seventy or so scrapbooks, of which many relative to local history are in the possession of the historical society. By 1939, the automobile had put the peddler out of business, and Charlie sold his wagon for fifteen dollars and figured he had put over 100,000 miles on it and fed 1,500 bushels of oats and 100 tons of hay to his horses.

After 1939, Charlie rode his bicycle all around town, always taking his camera with him. His bicycle became a trademark in his later pictures. He was for a time custodian at the Salmond School and jack-of-all-trades. He rode his bicycle well into his nineties and died one month shy of his ninety-ninth birthday. The Hanover Historical Society was able to purchase the wagon for $990 in 1988 and moved it back to Hanover. It was in pretty rough shape, but Bill Sides and the late Larry Slaney used their skill and Yankee smarts and restored the wagon. Charlie would be proud.

Now there was only one problem. The wagon was too tall to fit under the barn. It has been kept on the driveway level of the barn but takes up valuable display and work space. Through funds raised by the Historical Society and the Friends of the Stetson House, a three-bay carriage shed, designed by architect Doug Ulwick, was built to house Charlie Gleason's peddler's wagon, as well as several others, and all have stories to tell.

BEAL FAMILY OF ARCHITECTS

Public high school in Hanover was instituted in 1868 and was held in rooms in the town hall. In 1893, two wings were added to the central portion of the original building to provide for the expanding high school population. Local architect J. Williams Beal designed this addition, and his designs were to influence four later Hanover schools.

In 1878, J. Williams Beal, then only twenty-three and a recent graduate from the Massachusetts Institute of Technology, designed the Civil War monument. In 1884, he married Mary Howes, daughter of Dr. Woodbridge Howes, a local physician. They lived at 178 Broadway, a house built by Robert E. Dwelley in 1853. Here Mr. Beal made architectural changes and additions that reflect the "Beal" style, and it became known as "The Anchorage," a safe haven for their children to return. The renowned Frederick Law Olmsted designed the landscape for this house.

The Beals had five children. Olive founded the Hanover Garden Club. John Woodbridge and Horatio became active members in the J. Williams Beal firm of architects, which employed a staff of twenty-five trained specialists in the big Boston offices at 185 Devonshire Street. Robert became a landscape architect and lived in Wellesley, and Gerald became an agent and president of the J. Henry Schroeder Corporation, an international bank, and lived in New York City.

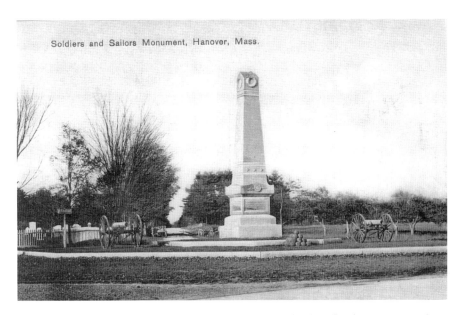

Soldiers and Sailors Monument, Hanover, Mass.

The Beal family designed many structures in town, from schools to fire departments to the Hanover Civil War Monument.

The firm of J. Williams Beal and Sons was especially well known for public buildings. J. Williams died in 1919, and the firm continued with the same philosophy under the direction of his sons. In Hanover, buildings designed by J. Williams Beal and his sons include the 1878 Civil War monument; the 1893 addition to the town hall; the Edmund Q. Sylvester High School, 1927; the Salmond School, 1931; the Center School, 1953; and Hanover High School, 1959; as well as several of the village fire stations. Among other structures elsewhere in the state, J. Williams Beal and Sons is credited with the designs for the old bridge over the North River at Union Street, Norwell; the Cole and Osborne Schools in Norwell; Whitman High School; Shrewsbury High; Rockport High; Kingston High School; Northampton High; the Granite Trust Company in Quincy; Quincy Masonic building; Bethany Congregational Church in Quincy; Marlboro National Bank; Athol Savings Bank; buildings at LaSalle Junior College; the Repertory Theatre in Boston; Plymouth County Hospital; and the Registry of Deeds building and the remodeled courthouse at Plymouth. The firm originated the design of the Howard Johnson restaurants.

Beal and Sons also designed many fine homes. It designed the "Castle in the Clouds" in Moultonboro, New Hampshire, for United Shoe Machinery investor Thomas Plant. In Hanover, John Beal designed the Calvin Ellis

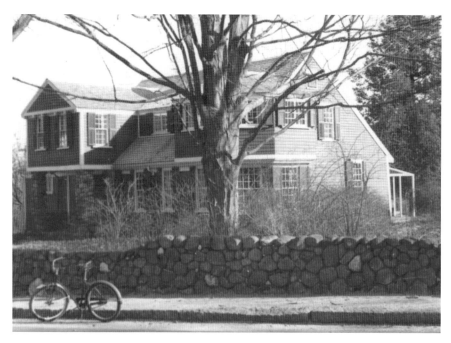

J. Williams Beal bought and renovated the oldest house in Hanover, 168 Broadway, for his son John and new daughter-in-law Grace when they married in 1915.

House on King Street, the Rose Sherman House on Broadway at the end of Oakland Avenue, a house for Carrie Cushing and one for Herb Chamberlain on Oakland Avenue. In South Weymouth, my father-in-law lived in a Beal-designed home, and I have learned to recognize some of the characteristics of their design in several South Shore communities.

John, the eldest son of J. William and Mary, was born in 1887. He married Grace Donovan of Rockland in 1915, and they remained in Hanover and raised their family here. As a wedding present, J. Williams renovated and restored the oldest house in Hanover, 168 Broadway, for the young couple. They later moved over to his parents' home at the Anchorage in 1930. John and Grace raised their four boys in the "little red house" and the Anchorage, and their son, Philip, and his wife, Barbara, raised their children in Hanover as well.

Phil is well remembered among other things as water superintendent and public works superintendent responsible for the water treatment plant and the Beal Bed Rock Well, both of which showed great foresight in solving water problems in Hanover. He was the third generation of his family to work for a good water system in Hanover. I interviewed Phil about his family

and began to realize the great contributions his family made to this town. The members of the Beal family were always public-spirited citizens and served our town well. J. Williams, or "Billy" Beal as he was called, was one of the founders of the Village Fire Association. He was followed by his son John, grandson Philip and great-grandson Peter in interest and service in Station No. 2 at Four Corners, which he designed.

Billy Beal served the town on many committees. He put bills before the legislature to put all utilities underground and to extend the Hanover Branch Railroad to Greenbush and make it a circular line. His son John, after putting in long hours at the firm, still found time to serve as town captain for the Board of Food Administration during World War I, as a member of the original Board of Water Commissioners and a volunteer at the fire station, and he spent many Sunday afternoons meeting with the Finance Board of the town. He also served as a commissioner for the Department of Public Works of Massachusetts from 1938 to 1942. His wife, Grace, was very concerned about education and served on the Hanover School Committee for many years. She was the local agent for the Society for the Preservation of Cruelty to Children, founded the local Tuberculosis Association, was active in the local garden club and visiting nurse association and served as the state regent for the Daughters of the American Revolution.

As your children return to school this September, many of them will be entering a "Beal" designed school, as they have withstood the years well. Remember the services this family gave to our town.

REMEMBERING LUCY BONNEY

I considered Lucy Bonney one of my good friends. Although the difference in our ages was almost 40 years and we had different opinions on many subjects, we shared many interests. Lucy died on March 31, 1996, at age 104, and I shall miss her. One can hardly remember Lucy without including her twin sister, Anne, who died in 1995. They were born in the family home on Old Washington Street in Hanover. They were the seventh generation of their family to live in that home.

They were told that they were so small when born that they were kept in a small box near the stove until they were big enough for cradles. Although they were not identical twins, most people could not tell them apart, but their close friends could. They grew up on a farm that was typical of the

Left: Anne Bonney shared many a story about her days growing up in Hanover.

Right: Lucy Bonney joined her sister in becoming a rarity: twins who reached one hundred years old.

early 1900s but would seem magical to children today. Playing in the hay mow, picking blueberries in the pasture, helping Mother and Aunt Lucy with the household chores, playing with the kittens and the ever present faithful dog, catching fireflies at twilight and taking long wagon rides to Duxbury to visit grandmother Weston were important parts of their early lives.

They took good care of the few toys that they had, some handed down from a wealthy friend in Boston, and when it was time to open the Stetson House, they donated their toys that had been carefully preserved in the attic. When you think of the changes that have taken place in the last century or so and realize that these women changed with them all, one cannot help but admire their spirit.

From the district school in Center Hanover to Radcliffe College, education prepared them for the challenges they faced. I once asked Lucy if they played a part in the women's suffrage movement. "Oh, we marched in Boston," she replied, "but we didn't tell Mother." Both young women became teachers, Lucy a teacher of high school English and Anne a school librarian. I'm sure their thirst and enthusiasm for knowledge were spread to the many

children whom they taught in Connecticut and New Jersey. We shared a love of reading, and I think I read most of the books on the shelves in their cozy library where we shared many a cup of tea. I remember sitting with them one afternoon in October after a particularly stimulating day of teaching my own fifth graders. I had been teaching a poem, but I couldn't remember the author. "Do you know the poem, 'October in New England'?" I asked. And they chimed in "And I not there to see, the glamour of the goldenrod, the flame of maple tree'; That was by Odell Shepard, our teacher at Radcliffe, the year he was in California."

Anne married a widower in mid-life and lived in Norwell; Lucy continued teaching, traveling in the summer and seeking new adventures but always coming back to the old home on Washington Street, where she retired. But retirement became a most active part of her life. She took part in many community and church activities, was a longtime member of St. Andrew's Episcopal Church and active in the altar guild and prayer group for many years. Interested in art and music, she took up painting, and I am pleased to own several of her paintings of local places.

Lucy and Anne were both interested in politics and were life-long Democrats in a Republican town. When Lucy received a birthday card in her advanced years from President Reagan, she huffed and threw it into the wastebasket. She didn't think much of him. Both the sisters were active in the League of Women Voters and avidly studied political issues. They attended town meeting until they were ninety-five years old. Lucy served on the board of directors of the Visiting Nurse Association for many years.

When I moved to town in 1964 with my family, my husband and I joined the then small Hanover Historical Society, which met in individual homes. We were the youngest in the group, but we were welcomed and learned so much. It was there that the Bonneys discovered I shared their passion: historical research. They were wonderful teachers, and as I asked question after question, they quenched my thirst about the history of my house, other old houses, the history of the town and the people who influenced its history. I joined with them in a project of researching the old homes in Hanover located on the 1850 map.

I would ride my bicycle down to their house many a summer morning. There on their screened porch we would immerse ourselves in the historical puzzles of the old houses and how they passed from generation to generation and family to family. In the afternoon, taking the history of a house as an entry, I would go off on my bicycle and visit and photograph the old houses, until we had done over one hundred of them. We eventually collaborated on a

book for the bicentennial titled *Houses of the Revolution in Hanover, Massachusetts*. Of course, all of this took a few years, and during those years, the Bonneys became my dear friends and part of my family. They were welcomed at our table at Christmas and Easter dinners. (They had other invitations from other friends for every holiday.) They were so positive in their outlook and so much fun to be around; they never lacked for invitations.

Anne and Lucy sponsored me as a member of the Hanover Garden Club, and we shared a love of gardening. Some of my prized possessions are the old daffodils, the dainty pink rose, the hyperion lilies and other old-fashioned treasures from their garden. When they were in their eighties, Lucy and Anne spotted a Newfoundland puppy and fell in love with her; she became their beloved Dinah. Dinah grew and grew and weighed more than each of them. She led them on a merry chase and helped keep them young. It was a sad day when Dinah died.

Lucy and Anne kept active and independent and remained in their much-loved old home until well into their nineties. There they greeted their friends who sought out their company. The sisters were very close and had a kind of telepathy. One seemed to know what the other was thinking. When they turned one hundred, they were recognized in the national news: one-hundred-year-old twins are indeed rare. A memorial service was held for Lucy Josselyn Bonney on Thursday, April 4, 1996, at St. Andrew's Episcopal Church. Those who were present counted Lucy Bonney as a wonderful role model and a true friend. May she rest in peace.

SCHOOL DAYS

The Little Red Schoolhouse

In the first seventy-five years or so after the incorporation of the town, schoolhouses were erected and paid for by the town. Then it became the practice for each district to finance its own school. But in 1850, the town voted to purchase the district school lands and buildings, and there was then some equality of education from one district to the next. In fact, the buildings were often constructed from the same plans.

The Whiting Street School was built in 1879, and it was the third building to occupy the site. Notes from annual town reports indicate that in 1879, Emma H. Ramsdells was paid $268 for teaching thirty-six weeks at the Whiting Street School. By that time, all teachers in the primary schools (one teacher for each of the eight district schools) were female. The high school teacher, Mr. M.S. Nash, was paid $675 for teaching forty weeks. The wages of all teachers had been reduced that year by approximately $3 a month due to lack of funds. They were raised the following year.

In the old district school, the teacher's desk stood on a platform in the front of the room. The blackboard was the front wall. Usually, the stove was in the middle of the room, and the stovepipe extended to the front or back of the school (depending on the location of the chimney), dispensing heat as it made its way to the chimney. Those who sat near the stove were plenty warm; those at the perimeter were often chilled. Sometimes the teacher had

Schoolhouses come and go, but sometimes a story can be told in something as small as Lot Phillips's collapsible tin cup.

to build the fire herself; at times, an older student was assigned this task. The children brought their lunches in a lard pail or basket. In winter, sometimes the teacher heated soup or cocoa on the stove. Of course, there was an outhouse in back of the school.

At first, many of the schools did not have their own wells, and someone was sent to a nearby neighbor for the daily bucket of water for drinking. It was not unusual to drink from a common dipper until the facts of disease communication were understood. Then a child brought his own collapsible tin cup. At the historical society, we have the collapsible tin cup that belonged to Lot Phillips.

District No. 5 School House closed about 1927. For a time, it was used as a storehouse for town belongings. At some time, it was sold. In the 1970s, Valerie Gibson Barker purchased it and did some work to make it livable and conducted a dance studio there. Judy Kirshner Baines bought it in 1979 from Susan Barnicoat, who had resided there for a couple of years. Judy strengthened the second-floor area and made two additional bedrooms there. She made changes in the kitchen and laundry areas for easier living. In 1984, David and Diane Haigh bought the charming old building and found it to be a wonderful home.

The Haighs found remnants of old school days in digging around the gardens: marbles, china doll parts, slate pencils, pennies and so on. The granite foundation of the outhouse has been transformed into granite benches.

There were seven other schoolhouses in Hanover, one in each of the other districts. District 1 was Center Hanover, and the little school stood

first beside the Stetson House, and by 1879, it was on the site of the present Sylvester School. I think that little building forms a part of the house at 339 Center Street. District 2 was near the Four Corners on Broadway and has been made into a residence at number 254. District 3 was South Hanover. In 1850, that schoolhouse was located on Cross Street, and by 1879, it was opposite 1194 Broadway. It, too, was moved and was converted into a house. District 6 was in North Hanover by Mann's Corner in 1879, and later came the Curtis School, built in 1896 to serve that district.

District 7 was the Rocky Swamp School, which served Assinippi and was located opposite the site of the Hanover Mall. District 8 was Main Street just north of Cedar Street in 1850 and 1879. The 1879 building was moved to 506 Main Street and served as a dormitory for the poor farm. It is interesting to note how many of the old schools went on to have other uses.

High school classes, which were instituted in 1868, were held in the town hall until 1927, when the Sylvester School was built. In 1879, when the new District 5 schoolhouse was constructed, all were proud of the new building, and many children learned their "three Rs" there. Some say that times were simpler then, but certainly not for the teacher, who had to plan lessons for children ages six to sixteen, clean the school, keep it warm and teach the eager and not-so-eager their lessons. Neither was it simpler for the students, who walked, some two or more miles, to school in all kinds of weather, sometimes providing their own books and supplies, sat in a hot or cold building, depending on the weather, and used the outhouse when necessary. Each period of history has its own challenges, as today does for boys and girls attending Hanover schools as well as the teachers who teach them.

HANOVER ACADEMY

Down at Four Corners, you will find an interesting old building that proclaims it was the Hanover Academy building, and indeed it was. Well, here is the story of Hanover Academy.

In 1808, the Reverend Calvin Chaddock, a 1791 graduate of Dartmouth College and minister of the First Congregational Church, saw the need for Hanover students to get a more advanced classical education beyond the eighth grade grammar school. He founded and became the teacher of Hanover Academy. It was first held in his home (623 Hanover Street) and later in a building described as follows by a former student of 1812: "The

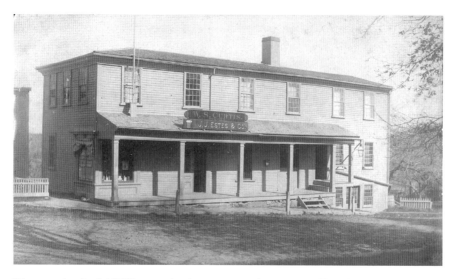

We recognize the "old" Hanover Academy as an antiques store at Four Corners, but it once stood at Hanover Center.

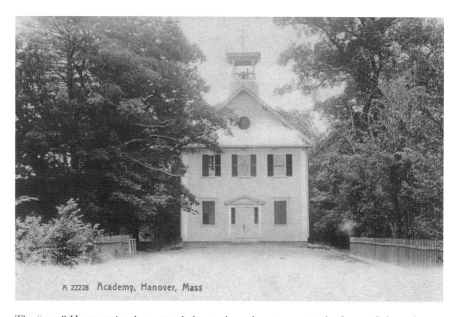

The "new" Hanover Academy stood about where the entrance to the former Salmond School is today.

building, which was owned by subscribers and proprietors, was located near the center of the town, a little west of the ancient parish church. It was tasteful, and even quite elegant, two stories high, of fair proportions, its walls neatly painted, furnished with Venetian blinds, and crowned with a cupola and bell." I would locate it in the area of the present ball field west of the Congregational church.

Reverend Chaddock continued as preacher and teacher until 1818, and his fame as an elocutionist was noted far and wide. To the minds of the youth in his charge, he was reported to have imparted the ardor of his own spirit in the pursuit of learning. He was followed by Reverend Chapin, who continued Sunday school here for a time until the building was sold in 1822 and moved to its present location at the Four Corners.

At the Four Corners, it did not remain as an academy but was utilized by Ephraim Stetson "for the storage and sale of strong waters." To some of the shipbuilders who frequented the place, it was referred to as "Stetson Shoals." The building has subsequently served as a general store, post office, lodge hall, telephone central office, shoe shop, drugstore, dental parlor, woodworking shop and antique store.

In 1828, a second Hanover Academy was founded and a building erected about where the entrance to the Salmond School is located today. Thirty-nine shareholders supported the undertaking, Samuel Salmond holding most of the shares. Unfortunately, we do not have a picture of this building. I understand that the boys were educated on the first floor. Two of the male teachers were ministers, among those being Reverend Calvin Wolcott and later his son, George Wolcott, and Reverend Cyrus Holmes. The upper floor was a very pleasant schoolroom for the young ladies, many of whom were daughters of residents of the Four Corners.

This enlightened addition came into existence as a result of a Young Ladies Seminary begun in 1847. One female teacher was hired to teach the girls. In 1850, Martin Paris McLauthlin became principal of Hanover Academy and was the last principal to teach in the old, or second, academy. In 1852, the third and new academy was built; the second one was sold for $352 and moved to High Street in Pembroke. The new academy stood about one hundred yards back from the road from where the old academy stood, on a more elevated piece of land about where the present Salmond School stands today.

Shares were again sold, Samuel Salmond again heading the list with forty-two shares taken. Mary Salmond, eldest daughter of Samuel, gave a bell reported to weigh four hundred pounds for the new school. The total cost of

the buildings, grounds and furnishings was $3,483.53. In the lower part of the building were the school rooms, while the upper hall was reported to seat more than three hundred people.

The hall was furnished more formally with furniture and a carpet and was to be used only for "educational, moral and Literary purposes." It was rented out for concerts, lectures and political, temperance and phrenology meetings, as well as sewing circles, fairs and festivals. The new academy was dedicated in March 1852 with great pride and sanctity of purpose. "Literature and Science having long enjoyed here a temporary dwelling place, have at last consented to be installed in this new temple." So stated Reverend E. Porter Dyer in his dedicatory address.

McLauthlin continued in the new building until 1854 and was followed by a number of talented, educated teachers. Their influence on the education of many young men and women, alumni of Hanover Academy, has echoed through the years. Broadoak School, District No. 2 Grammar School, was located nearby, and I found this little poem, handwritten on a scrap of paper, which seemed to indicate some friendly competition between the academy and the local public school.

The Academy pigs put on their wigs
And down to Broadoaks run,
The Broadoaks rats put on their hats
And chase them back for fun.

Hanover Academy had some competition from Assinippi Institute, which was founded for like purposes. Public high school courses were initiated in 1868 at the town hall, and over the next twenty years, enrollment at the academy declined. The last graduation exercises at Hanover Academy took place on June 26, 1892. The building was then leased to the town for several years for use as a public school, and in 1899, it was voted that it be sold to the town. At the March 1900 town meeting, it was voted to purchase the academy building for $500, and subsequently in recognition of the Salmond heirs and their service to the town and community, it was voted to be renamed the Salmond School—and so it served for thirty years.

In 1931, a new six-room Salmond School was built through the generosity of Mrs. H.K. Hatfield, Samuel S. Sylvester and Edmund Q. Sylvester, who gave $25,000 toward the new school. J. Williams Beal, George J.J. Clark and the Odd Fellows gave generously to the building of this new school. The old building was moved to Pembroke, I think, but the bell was saved and put in

the "new" school. This Salmond School was the pride of the Four Corners and the town, and when it was voted to close it in 1980, there was much nostalgic opposition.

This excerpt is from a poem by Augusta Briggs written for a Hanover Academy reunion:

The boys and girls of former years
Are scattered far and wide,
And many have achieved success
Which all have viewed with pride.
And we, the veterans of old,
Our days of youth renew,
Knowing in this Academy
We learned the most we knew.
All honor to our public schools
Which give with generous hand
A liberal education
To all from every land.
And let us view without regret
This old door open still
And welcome those with outstretched hands
Who come our place to fill.

HANOVER HIGH SCHOOL 1868 AND BEYOND

Public high school classes were instituted in Hanover in 1868 and were held in the town hall. One of the reasons that the town hall was enlarged in 1893 was the need for more rooms for the high school and a room for the library as well. This served for a while, but as the population gradually increased and more children—instead of dropping out after eighth grade—continued on into grade twelve, there was agitation for a new high school.

Town meeting in 1926 must have been much like a recent town meeting where most agreed that more space was needed for public education, but there was a great deal of discussion about cost. "We can't afford it!" the cry was heard. Then up rose Edmund Q. Sylvester, a bachelor with no children but who knew the value of public education. "I will donate $50,000 for a new high school," he said. Lot Phillips then rose and said, "I will give

twenty acres of land in the town center." Samuel Sylvester, Edmund Q.'s half-brother, donated $10,000. J. Williams Beal and Sons, an architectural firm from Hanover, designed the building, it was named the Edmund Q. Sylvester High School, and it opened in 1927.

Then came the Depression, and these were hard times. There were few jobs, especially for high school boys, so they stayed in school. In 1932, the high school classes increased from thirty-five to fifty, minimum. When space was short, rooms in the town hall were again used for classes. After the war, the population grew, and a four-room addition was built to the Sylvester School that housed grades seven through twelve, but new homes continued to be built, and with the news of the extension of Route 3, the population exploded.

In 1957, five building committees were studying school buildings and additions. A joint Norwell/Hanover High School was proposed. Hanover voted for it, but Norwell was against. Back to the study committee the town went, and in 1958, a new high school on Cedar Street was built. The Sylvester School was then used for fifth and sixth grades, which had been using some rooms in the town hall. By 1964, enrollment had increased, and an addition to the Cedar Street High School was built.

In the following years, as curriculum has been updated, so the high school kept pace with the times. Hanover High was one of the first in the area to

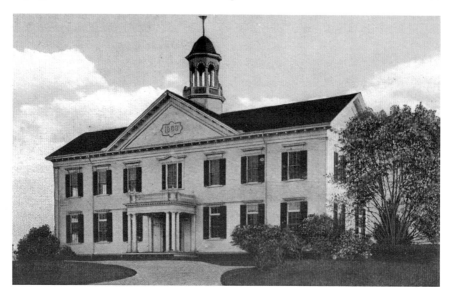

The town hall served as a high school until a new one could be constructed in 1927.

The third purpose-built Hanover High School opened in 1958.

have a computer lab, and in its newest iteration, opened in 2011, continues to be on the cusp of the latest technology. The high school experience today is a far cry from when Charles Miller attended high school in the town hall rooms. He recounted some of his experiences in *A History of the Miller Family in Hanover 1910–1935*, which he wrote for his children but is of interest to all Hanover people and can be found in the John Curtis Free Library.

> *The commercial room was next to the lab and one day the commercial teacher was absent. So we decided to make some hydrogen sulfide gas, putting the outlet hose through the keyhole of the connecting door to the commercial room....Of course the gas we were making is known as the rotten egg smell. When it reached the busy students, they threw open the window. But the breeze was flowing from that direction so it blew the gas into the rest of the school. The teacher in the room at the far end was made sick by the smell and went home. This cut the four teacher staff, including the principal, in half.*

Ah, but they were doing "hands on" science even then.

Agnes Nawazelski, a former Hanover teacher, graduated from the town hall high school in 1924. Agnes described the layout as quite different from today. She said that in the old days there were two doors into the main hall, where the entry hall is now. There was a small platform at the front where the principal, who also taught math, sat. This room was also used for an assembly hall and a study hall. To the left was the language room where she studied French, and to the right was the commercial department, where

typing and shorthand were taught. Behind the main hall was the English and science room. Agnes said,

> *There were only six girls in my graduating class, and no boys. We didn't have any organized sports. We had a basketball but no baskets or gym. The boys (there were boys in the other classes) did have a baseball team. My graduation was held in the big room upstairs that is now divided by a corridor. Sometimes on rainy days we girls were allowed to go upstairs and practice dancing. That's where I learned to dance.*

Agnes related that bus service to the high school had just been initiated. At first, it was a horse and wagon from Kingman's, but then a motorized "barge," an open truck with benches on each side, was used to pick up the students from Drinkwater, North Hanover, South Hanover and the Corners.

"Things have sure changed," Agnes said. However, as we look back, many of the issues are still the same: the most important being good public education. "The more things change, the more they stay the same."

EDMUND Q. SYLVESTER, HANOVER BENEFACTOR OF THE PAST

Have you ever wondered how the Sylvester School got its name? If you look carefully, you will see its full name, "The Edmund Q. Sylvester High School." Who was this Edmund Q. Sylvester?

Born in Hanover in 1869, Edmund Quincy Sylvester was named after his father, who built the mansion house at 65 Washington Street near the North River in 1850.

Edmund was the first son of his father's second marriage. His mother was Eliza Salmond Sylvester, sister of his father's first wife. Edmund had a half-brother, Sam, and a half-sister, Eliza, as well as three younger brothers. You might say Edmund was born with a silver spoon in his mouth.

The Sylvesters were by far one of the wealthiest families in town, the Salmonds being another. E.Q.'s father died in 1898, and David Ford, in his *History of Hanover Academy*, described the family as "one of great wealth, yet liberal withal…seldom refused to help a needy applicant who was known to be worthy." Edmund grew up in a family most generous with their wealth, and he continued in their benevolent manner.

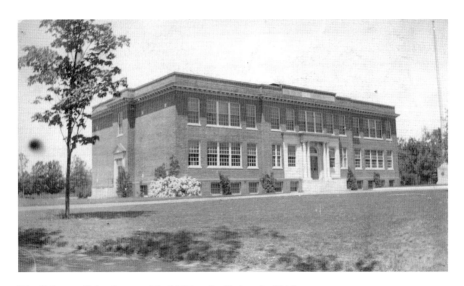

The Sylvester School opened in 1927 and will close in 2019.

The Sylvesters were communicants at St. Andrew's Episcopal Church and most generous in their support. E.Q. attended Hanover schools and graduated from Hanover High School, which was then located on the upper level of the town hall. He continued his education at St. Paul's School at Concord, New Hampshire, and graduated from the Massachusetts Institute of Technology School of Architecture. He followed his vocation as an architect, and among the buildings he designed was the John Curtis Free Library, for which he served as a trustee and treasurer for many years.

He was very much interested in town affairs and particularly the schools of the town. In 1926, there was a great discussion on the town meeting floor concerning the need for a new high school. E.Q. Sylvester rose and stated that he would give the town $50,000 for this purpose. His half-brother, Samuel, gave $10,000 and Lot Phillips gave twenty acres of land. The total cost of the building was $144,480.47, and Edmund Q. Sylvester had started the ball rolling by giving one-third of the cost. It was voted to name the new high school the Edmund Q. Sylvester High School after this man who valued education for the youth of his town.

He continued to be an active alumnus of Hanover High School all his life. E.Q. never married but lived with his mother in the homestead on Washington Street. After she died, he continued to live in his childhood home until his own death in 1942. In his obituary it was written, "Edmund Q. Sylvester will be remembered in his native town for his countless kindnesses,

his unswerving integrity, his modest helpfulness and his great generosity." Although it would be unusual for a citizen to have the means to give one-third of the cost of a new school, our people today would do well to support education, their churches and their town by giving of themselves, serving on committees, becoming knowledgeable about issues, attending town meetings and voting on issues that will help Hanover retain its caring spirit for all its people. Edmund Q. Sylvester gave us an example to follow.

SALMOND SCHOOL

The Salmond School has made the successful transition from elementary school to administrative offices.

The present Salmond School was constructed in 1931 on the site of a town grammar school, which had previously served as Hanover Academy, a private high school. The old school had been constructed in 1852 with money invested by stockholders, many of whom were from the Four Corners area who had children attending the academy.

Samuel Salmond was the primary stockholder. His eldest daughter, Mary Salmond, donated a four-hundred-pound bell to hang in the belfry. The bell cost $138 at that time. When the academy closed in 1900, the Salmonds and other stockholders turned the building over to the town with the stipulation that the bell continue to be used to call children to the classroom. The promise was kept, and the school bell continued to ring three times a day. The old academy was used as a grammar school and replaced the Broadoak School.

"The year 1931 will be always remembered in the annals of the Town of Hanover as the year of the opening of the new Salmond School. This building was made possible by the great generosity of the Sylvester family." So states the report of the School

Committee in 1931. Mrs. Hugh Hatfield (who was Elizabeth Sylvester), Samuel S. Sylvester and Edmund Q. Sylvester gave $25,000 toward the new Salmond School. J. Williams Bell, George J.J. Clark and the Odd Fellows were also contributors. The building committee was Edmund Q. Sylvester, Earl Shepherd and Joseph Church.

The little old white building was moved from its foundation (to Pembroke I think), and a new brick building was erected to take its place as a modern school. The old bell from the old academy building was saved and hangs today in the belfry, rung for many years by the elementary children who attended Salmond School. The new building housed the first six grades from Hanover, South Hanover and Center Hanover and the fifth and sixth grades from North Hanover. From 1938 to 1978, many children in town attended the family-oriented Salmond School and became very fond of it.

In 1978, there was great controversy. It was proposed that Salmond School be closed for economic reasons and the students from that district be bussed to Center School. Many families had a special feeling for this homey school, but economics won out and the Salmond School was closed and the bell silenced. The school remained empty for only a year or two until it was rented out to a private day care and preschool center. It currently houses the administration offices for the superintendent of schools, several other town offices and the North River Commission.

AROUND TOWN

THE HANOVER MALL SITE

Washington Street, so called "The Country Road," as it runs from Assinippi to the old bridge at the North River, is one of the oldest cartways in town. Originally "The Old Bay Path," it was the way made by the Indians and later widened by the horses and wagons of the early settlers on their journey from Boston to Plymouth.

The Third Herring Brook was located just to the east of the old road and meandered parallel to it. It was the inland path as opposed to shore route that went through Scituate. The Country Road was woodsy, rocky, hilly and marshy in various places. On an October day, it must have been a sight to behold. On a spring day, it was probably a muddy mess. Just about where the present exit from the expressway enters Washington Street was low land, and it was rocky and swampy. On the old maps it is designated as "Rocky Swamp." Just to the north of "Rocky Swamp" was the district school, which took the name Rocky Swamp School.

In the diary of Fanny Allen Simmons (1855–1928), who lived just north of the Rocky Swamp School, she wrote of the huge mosquitoes that plagued the children as they played outside. The historical society has a mosquito and fly trap that was used by the Simmons family. I'm not sure how effective it was. Mrs. Simmons also wrote of gathering wildflowers in the swampy and woodsy area where now stands the Hanover Mall. She listed cowslips,

Before there was the Hanover Mall, there was the Rocky Swamp neighborhood and even a Rocky Swamp district school.

violets, Solomon's seal, Jack-in-the-pulpit, columbine, pitcher plant, star flower and shadbush among others. I wonder how many of these still grow in the nearby woodland on Mill Street.

Mill Street intersected Washington Street. Both ways were lined with stonewalls. Mill Street still has wonderful old stonewalls bordering its edges. On Mill Street just south of Rocky Swamp, very near the Mall Cinema, was located the early Curtis Mill. After the Curtises, T.J. Gardner, who married into the Curtis family, owned these mills until they were later owed by Samuel H. Church, who married Gardner's daughter. The mill stayed in the family for three generations.

Of course, the area described above is the location of the present-day Hanover Mall. Along "The Country Road" were countless old capes, colonials and early farmhouses. The Simmons House was one of the larger homes held by one of the larger land holders. It was torn down in 1962 to make way for the expressway. On the 1850 Map of Hanover, there were nine old houses from Assinippi to Mill Street; only two remain.

Of course, I know I romanticize those old days when the roadways were dirt, the horse and buggy were your transportation and you knew your neighbors and village folk. The automobile certainly brought about one of the biggest changes to all our small towns and cities. In the 1950s, when these nine old houses still were standing and twenty others had joined them,

people would sit on their front steps and porches on a Sunday evening in the summer and watch the traffic wind its way slowly up from Cape Cod, bumper to bumper, right past their front doors.

To eliminate this congestion came the Southeast Expressway. It brought people not just through Hanover, but they moved into Hanover, and our little town grew to be not so little. Our new citizens needed a place to shop—a supermarket, bank, department stores—and the kids needed a movie theater to keep them out of trouble. So we were told at the town meeting in 1969 to accept a change in zoning in the Rocky Swamp area. And so came the Hanover Mall. For the most part, the mall has been a good neighbor. It has provided convenient shopping, jobs and recreation for teenagers. It hosted two wonderful balls during the bicentennial years. It hosted a Centennial Ball for the year 2000. It has been generous to the community.

We cannot go back to the "good old days," but we must respect those values of an honest day's pay for an honest day's work. We must not forget our humble beginnings. And we must look for the wildflowers and save them where they are left. We must treasure "the little pleasures of life."

THE OLD SIMMONS HOMESTEAD

The old Simmons homestead was located on the west side of Washington Street on the so-called "Deadman's Curve" about a quarter of a mile south of the Assinippi four corners intersection. The house was torn down to make way for the Southeast Expressway in the early 1960s. Across the street was the old barn for the animals, and according to resident Catharine Phillips, writing in 1954, a "lane leading to a rocky pasture where a rippling brook made a pleasant sound. Beyond the brook lay a pine grove where the Simmons and Phillips children loved to play."

This is the area sometimes called Rocky Swamp, and it is now the location of the Hanover Mall. The rippling brook is Third Herring Brook, which marks the boundary of Hanover and Norwell. Washington Street (part of the Pilgrim Old Bay Path) is one of the earliest roadways, beginning as an Indian path, probably only a few feet wide, "winding in and out through the trees of the 'forest primeval,' over stepping stones through the lower grounds," according to John Simmons, writing in 1908.

It was then used by the early colonists, who later rode horseback. Later called the Country Road, it was officially laid out in 1656 by Hanover's first

The Simmons family lived in this house about a mile south of Assinippi Corner, but it was torn down to make way for the Southeast Expressway.

settler, William Barstow. The original path was gradually widened to make way for carts and carriages and eventually straightened and widened further for the automobile. Along this early roadway, many of our earliest homes were built. By 1849, there were twenty-nine houses shown on the Whiting map from Assinippi to Hanover Street. Of these twenty-nine, only six are left standing, many taken down since I moved here in 1961. Of these six, three are on "Old" Washington Street and were saved by the earlier straightening of the road. So much of our history has been destroyed.

To keep the history of the old Country Road alive, I will tell you about the old Simmons Place. It was probably constructed about 1750, though there is a question if parts of an earlier house were used in the ell. It may have been built by an Otis, but by 1782, David Jacobs was living there. It began as Colonial in style but was "Victorianized" in the late 1800s by the Simmonses, who came into possession in 1799 at David Jacobs's death.

Elisha Simmons, great-grandfather of John F. Simmons, author of *History of Hanover*, was a blacksmith. Here he raised ten children, one to become a judge, one a clergyman, one a doctor, one an artist whose *The Return of the*

Flags and *The Battle of Concord* were displayed in the rotunda of the State House in Boston, and one, Ebenezer, who inherited the property and kept a store in the ell. Ebenezer was a lieutenant in the War of 1812 and was at one time in command of the fort at the entrance to Plymouth Harbor (the Gurnet, at the southern end of Duxbury Beach).

Ebenezer's son Perez became a lawyer of some renown, and a biography of his life was written in *The History of Plymouth County—1884*. He was educated in the village school and then given private instruction by the Reverend Samuel Deane, author of *History of Scituate, 1831*. He entered Brown University and was admitted to the bar at Providence. After practicing in Rhode Island a short while, he returned to Hanover and took up the practice of law in the home of his childhood. During his forty years at the bar in Plymouth County, there are few leading cases where his name does not appear.

In 1846, Perez Simmons married Adeline Jones of South Scituate (now Norwell), and they had three children. Their daughter, Sophia, married Morrill Phillips of South Hanover. Their younger son, Moses, was a graduate of Harvard Medical School, and John Franklin Simmons, their elder son, became a lawyer like his father and lived in the house with his father and mother, wife and four children. John Simmons was a well known and respected figure in Hanover. He was an eloquent speaker and strong supporter of public education. He served on the school committee for fifteen years. He kept law offices in Hanover, Abington and Boston. John Simmons married Fannie Allen, the local minister's daughter, and they had four children.

The historical society is in possession of the diaries of John Simmons's wife, Fannie Simmons, and the daily life of this local Victorian family is wonderful to read. The diaries describe the warm kitchen with the big black stove, the dining room where one of the many parlor stoves was kept burning, the small office lined with tall bookcases and filled with leather-bound law books, the bay windows and piazza, Ma and Pa Simmons (Mr. and Mrs. Perez Simmons), family gatherings and holidays, as well as day-to-day life.

Through the years, the old house held many memories of the Simmons family, and fortunately, some of their mementos have found a home at the historical society. John Simmons died prematurely in 1908, and the family home eventually fell into other hands. For a time, it was divided into apartments. Traffic increased to a steady stream as Washington Street became a main route to Cape Cod. Then the Southeast Expressway cut through the Simmons's pasture and hop yard. The house was torn down, and we are left with the memories of a grand family and wonderful old house.

OXEN IN DAYS OF YORE

I'm sure every Hanoverian has marveled at the miles and miles of stonewalls that line the streets and lanes and crisscross the fields in our old town. Having just added a mere 150 feet of stonewall to define my property from Main Street, I have a greater appreciation of the work and skill involved. My self-built wall is not as sturdy or as wide as those of old, but I am learning. It took many rocks and a few stones to construct my wall, and I gathered many of them myself from my property and some from as far away as Connecticut and Rhode Island. However, I had a professional wall built around a garden to the rear of my property, and the wall builders there wanted more choice for their more perfect wall, so additional rocks were purchased. (You wouldn't believe how much they cost.) Those left over were then moved (by machine) to the street edge of the property for me to build my "country" stonewall.

Most of these rocks were very large. In the old days, the farmer certainly never purchased a rock. In fact, part of the story of New England stonewalls is that the stones were worked into walls as the rocky fields were cleared. But the old farmer had a helper to move the rocks, his loyal ox, or more likely his pair of oxen. Oxen can be credited with helping the farmer clear the forests, drag the large trees out, pull the stumps and haul the large boulders and rocks to the edge of the field where the stones were later carefully fit into a fine wall defining the field. In the winter, the oxen were hitched to a large sled and the burden pulled across the snow. When there was no snow, a stone boat or cart was hitched to the yoked oxen.

Probably most of the rocks for the old stonewalls in Hanover were hauled into place by a yoke of strong oxen hitched to a heavy homemade cart or sled. Resident Helen Whiting wrote, "The loads oxen could pull is almost unbelievable. They had the drawing power of several horses, and a farmer could feed 12 oxen for the price of one horse."

Now I must answer the question some of you former city dwellers are asking. What is an ox? To be polite, I will couch the answer in Victorian terms. An ox is male cow that has been "altered." Every bull cow was a potential ox and a source of great usefulness as a draft animal. Two hundred years ago in Hanover, there were twenty oxen to one horse. The reason was purely economics and logic. The oxen thrived on a diet of pasture grass and hay and were less susceptible to disease. When age made them unable to work, they could be slaughtered and eaten or sold. It is little wonder that they were so used and valued.

Horses worked for a couple of hours and demanded food; oxen, like those of Sam Sylvester shown here, were much more industrious.

At the beginning of the nineteenth century, a pair of good oxen cost seventy-five dollars without their yoke. Every farmer needed at least one yoke of oxen to run his farm. Oxen were used for any heavy job. They would pull a cart of hay or produce. They would drag the granite in place for the foundations of the old houses. They would drag the huge oak timbers across the fields to the shipyards for the construction of those ships that were launched on the North River. One could hear the driver directing his beast as he yelled, "Haw" (go to the left), "Gee" (to the right) and "Buck" (move back). "Shh" was the signal to stop quickly. This was the universal language understood by both the driver and the oxen who communicated well with each other.

Oxen could travel over rough ground easier than a horse, and a broken leg was unlikely on an ox, which had sturdier legs and cloven feet like a cow. The blacksmith had to make two shoes for each foot of the ox. It was quite a job to shoe an ox. Weighing two thousand pounds and often more, the huge animal was hoisted up in a frame and a leather sling passed beneath its body. When the animal was off the floor, then the feet were bound to low side posts, and the blacksmith would begin his work. I have an ox shoe found in my field by Lot Phillips years ago, left by one of those beasts of burden who worked to pull out the large pine trees that were to be made into boxes.

Three yoke of oxen could move a building and often did. Many of the old schools were moved about town; shoe shops were moved, as well as small houses. The ox was a reliable animal and bore his burden well. Sam Sylvester, half-brother to Edmund Q. Sylvester, had the last pair of oxen in Hanover. These were in use many years on the Sylvester farms but were replaced, as were others in town, by the motorized tractor, which would do ten times as much in the same time, according to historian Charlie Gleason, who said in 1942, "Sam does not use oxen, [anymore] but he likes to see them around just to remind him." Charlie photographed week-old twin calves that sometime in the future would grow up into big oxen who would weigh a ton or more each. Their names were Pete and Repete. Pictured with them was Fred Saunders, who was caretaker on the E.Q. Sylvester farm and later worked for Dr. Hatfield. The days of oxen are long gone from Hanover, but the miles and miles of stonewalls remind us of those days of yore.

THE HANOVER BRANCH RAILROAD

Hanover once had its own "branch" railroad. Many Hanover business leaders worked hard to bring rail transportation to our town beginning in 1846 until 1868, when the first train ran over the tracks from Hanover Station, located just behind the building at 303 Columbia Road (which recently served as Santander Bank), across from the site of the old Sylvester's Hardware.

It continued down along the Indian Head River to Curtis Crossing just above Elm Street, along the river to the South Hanover Station, thence across Cross Street and the fields behind Tindale's Pond, crossing Myrtle Street and Circuit Street at Winslow's Crossing and on to the West Hanover Station, Rockland and Abington

Joseph Merritt, newspaperman of the old *Rockland Standard*, tells of the "dummy" train. When the Hanover Branch was built in 1868, the rolling stock consisted for a time of three secondhand passenger coaches and a small locomotive. The company also experimented with what was known as a "dummy," a short double-ended affair with but little power. It seemed a dinky little toy and created much amusement among the patrons of the road and was replaced in a short time by a regular wood burning locomotive. A Hanover man by the name of Harvey MacLauthlin was engineer and made a funny little sketch of the dummy.

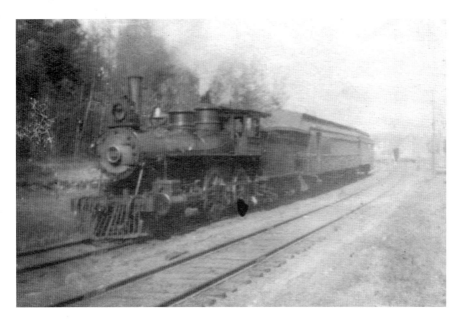

Railroads lasted for less than a century in Hanover, but the arrival of the first steam engine, shown here, caused a stir.

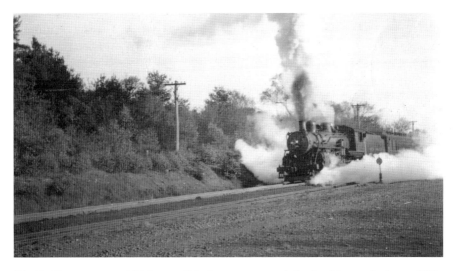

Charlie Gleason captured this image of the last passenger train leaving Hanover in August 1938.

Helen Whiting, Hanover born and a former Hanover schoolteacher long before my time, told several stories about the beginnings of the Hanover Branch in her writings for children filed at the historical society. She wrote of two old West Hanover men who could not see the need for the new railroad. "One said, 'Now here is Randall's coach doing all the business there is to do. It comes through here twice a day. It ought to be here now. Let's see how many there are aboard.' Soon the rattle of the old coach could be heard, and a cloud of dust appeared far down the road as a four horse coach came into view with one solitary passenger."

On the contrary, the branch did very well in both passenger and freight service until the automobile became king. Whiting also wrote of a riot caused by the dissatisfaction of the railroad firemen, who planned to strike unless Mr. Perry, the president and founder of the railroad, would grant five dollars per day, shorter hours and several other things. A messenger was sent to give the message to Mr. Perry, who got so incensed that he crumpled up the paper and shouted, "Never!" The frightened messenger took the reply back to the firemen, who, when they heard what had happened, stamped up the track toward Rockland like an angry army. "There were blows, kicks, scratches, black eyes, bloody noses and yells of anger, but in all this excitement there was only one casualty, a man with a bitten ear. Finally a settlement was reached and the crowd was treated to free ice cream."

Mr. Joseph Church, an old time Hanover resident, wrote about his days on the railroad in a paper he delivered to the Hanover Historical Society in 1965. He told of applying for a position of engineer. Mr. Collamore, whose name Joe had given for a reference, came right up to talk to Joe's grandfather, who thought Joe would be better fitted for office work rather than an engineer. Grandfather said, "Never in my life have I seen two boys [Joe and his brother Arthur] with so little mechanical ability....Neither one of you could put a button on a privy door."

Joe Church did get a job as assistant station agent for two years, from 1902 to 1904. "There I spent two happy years....I reported at 5:15 in the morning and worked through 7:45 at night, six days a week—$7.50 a week."

Charles C. Turner, who was a newspaperman in the first part of the twentieth century, had a great affection for the railroad and wrote many articles against its closing. He recalls the days when "one could hardly get through the [railroad] car because of the presence of egg crates, boxes of soap, mail bags, etc...bulky packages (in the passenger car racks, sometimes in the owner's laps, sometimes in the baggage car) ornaments that adorn the

rooms of the Mid-Victorian houses for a half-dozen miles around....This proves my statement that about everything came home to Hanover..."

And then Charlie Gleason had many tales to tell in his notebooks. Charlie drove his horse and wagon—and later, his bicycle was his mode of transportation—but on a rare occasion, he took a joyride on the Hanover Branch. He tells of the Tower brothers who lived in town and worked on the railroad. Frank was a conductor; his brother, Fred, was an engineer; other brothers served as fireman and baggageman, and the train was called the "Towers Special." There are still a few people in Hanover today who remember riding on the Hanover Branch Railroad. I urge them to write down their memories of those times, or they will be lost.

HANOVER FOLLY

There are always those who resist change. I may be one of those who are reluctant to change the "status quo," so I can understand how Captain John Cushing felt in the late 1850s when the town proposed to cut his land in half, right through the middle of his pastureland, and make a shortcut from Hanover Four Corners to Hanover Center and onto Rockland. Captain John's land stretched from Church Street next to St. Andrew's (in fact, St. Andrew's was built on land he sold to them), the old rectory, presently 288 Washington Street, westward to the location of the present Social Security Office and the Citizens Bank (250 Rockland Street), and farther west for a total of fourteen or so acres.

Captain John felt that the old way was good enough for past generations and was still good enough for future ones. The old way followed Washington Street from the corner of Church Street, on past the old Sylvester houses (now Cardinal Cushing School), on to the present location of the VCA Roberts Animal Hospital (516 Washington Street) and around the hill on Old Hanover Street to meet the Drinkwater Road (present Route 139, Hanover Street). The new road, now called Rockland Street, would shorten the distance quite a bit, running a straight line from the corner of Church Street down the hill through Captain John's pasture and up that steep hill past the present transfer station to where Richardson's Insurance Office is now located (205 Hanover Street).

Imagine trying to get the poor horses to pull your wagon or sleigh up that hill through the snow in the winter, and it would be even worse with the

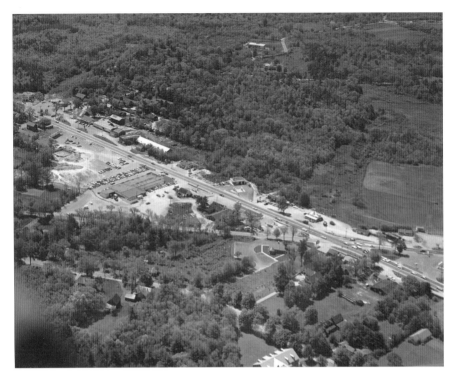

Captain John Cushing was not at all excited about the idea of the laying out of Rockland Street, running left to right through the middle of this aerial photograph, when the town proposed the shortcut from Four Corners to the Center in the 1850s.

mud in the spring. Captain John was so incensed at the town taking his land and building such a road that he put up a sign at the end of Church Street by his house, which stood at the location of 1 Church Street. The sign read "Hanover's Folly." This name stuck for a long time, and the present Folly Hill development derives its name from this piece of history (or folklore).

Captain John Cushing instructed that when he died his body should be carried the long way around old Hanover Street to the cemetery at the Center. His wishes were carried out, and when he died on October 30, 1871, his bearers walked the whole distance, one at each wheel of the funeral carriage. When the Folly Road was put through in the early 1860s, Jedediah Dwelley was selectman and road surveyor, and the new road cost about $1,500, which was a lot of money in those days. The road was dirt, lined with pine trees and birch. It had to cross over Trout Brook as it made its way up the hill to rejoin Hanover Street. Most people today don't know the story. Was it Hanover's Folly, or was it not?

THE LONE HOUSE IN CRICKET HOLLOW, OR THE CRICKET HOLE HOUSE

These are the two old names used to describe the old Cape-style house at Cricket Hollow that was destroyed by fire one Fourth of July in the 1920s. It was located on a road that was once a public shortcut from Scituate to Abington. It went from Tiffany Road (now Norwell), the area of the old Stockbridge or Tiffany Mill, through the woods in back of the present Cardinal Cushing School, crossing Washington Street, south of East Street, around Randall's Swamp and came out on Hanover Street (then called the Drinkwater Road) near the present tennis and basketball courts.

There were boggy places near the Cricket Hole, and bog iron was dug from this area. The iron pellets were melted down and used at the forge at the Curtis Mill at Luddam's Ford. The house stood way back in the woods on property now owned by Cardinal Cushing School, and a path still leads to its location. Descendants of William Palmer, who built the first bridge over the Third Herring Brook at the now Hanover-Norwell line on River Street/Broadway in 1680, probably built the house as a small farm.

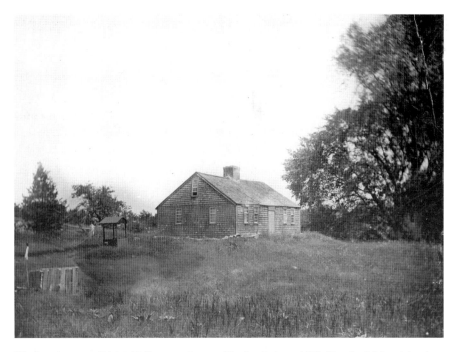

The lone house at Cricket Hollow was destroyed by fire during a 1920s Fourth of July celebration.

Roger Leslie led an expedition to find the house at Cricket Hollow, succeeding in finding the cellar hole, in the 1980s.

By 1724, the property belonged to the Sylvester family. I found a deed from Josiah Palmer to Amos Sylvester of that date for property in that location. Robert Sylvester, in valuations of 1860 and 1876, referred to it as "my Palmer Place" and rented it out to various families. It was just a little farmhouse in the woods, but it had a story to tell.

Those of you who have read Longfellow's poem "Evangeline" know who the Neutrals were. Just before the French and Indian War, French families were driven from their peaceful homes in Grand Pre, Acadia (now Nova Scotia), by King George because they refused to swear allegiance to the English Crown. They were scattered far and wide and were billeted upon the colonies, one family to each town along the Atlantic coast. In most towns, the location of these families seemed to be in secluded spots, perhaps because at that time, the French were looked down upon in America. And so, in Hanover, "Cricket Hole" seemed quite secluded and a good place for them.

Their lack of acceptance in the community can be illustrated by the tale of Peter Trahan, a Neutral passing through who reportedly found a silver watch, which he gave to a countryman to return to its owner if reported lost.

The owner had Trahan arrested and put in jail for four days until he paid five pounds. The same Trahan complained to authorities of the Massachusetts Bay Colony that the selectmen of Scituate had placed hardships on him and his brother.

How long the French Neutrals stayed at Cricket Hole has not been recorded. Many were on their way to Louisiana, and some made it there, accounting for the French influence in that part of our country. Later, a family by the name of Donnell rented there for a time. John Milton Dwelley recorded in his diary on December 13, 1849, "Came to Cricket Hole to live." I doubted if the crickets were chirping then, but he probably heard them in the spring. He raised sheep here, carried the mail and did errands for those who lived on the way to the Four Corners.

The last family to occupy this lonely house far from the main road was the Loatmans. "Peanut" Loatman later moved to Old Hanover Street. Colonel John Osborne bought the Sylvester property in 1919 and ran a restaurant called the Iron Kettle Inn in one of the Sylvester houses on Washington Street (now run as Iron Kettle Inn by the Cardinal Cushing School). Colonel Osborne was an officer in the state militia, and he invited the militia to hold maneuvers in the woods around the Cricket Hole site. The old cellar hole is still visible. The historical society had an exploration there several years ago and found evidence of the old house location and well.

THE VILLAGE OF SOUTH HANOVER

From its earliest development, Hanover settlements clustered around a crossroad, a river or brook that could be dammed or a small waterfall. South Hanover had a narrowing of the Indian Head River dammed probably as early as 1720, and several industries worked on this site through the years. An iron forge was one of the earliest, followed by an anchor shop and a gristmill. Later, bar iron and tacks were made here.

In 1853, E. Phillips and Sons tack factory was in business here. It consisted of over a dozen buildings and two furnace stacks and stretched across the town line into Hanson. Atlas Tack Company purchased the business at the time of World War I. The buildings were eventually torn down—except for a small one still standing, used for a time as a liquor store. The dam was destroyed by the hurricane of 1938, and only remnants remain.

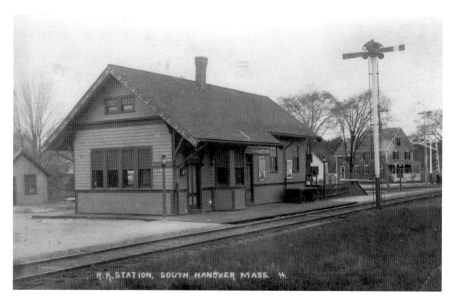

The small village of South Hanover had its own train station linking it with the outside world.

E.Y. Perry was a vital force in the development of the village of South Hanover. He was an entrepreneur and had interests in many businesses, one of which was the tack factory in South Hanover. Because of his business interests, he was vitally interested in encouraging the development of a railroad to transport needed materials, finished products and passengers. Under his leadership, the Hanover Branch Railroad made its first run in 1868, and one of the three stations in Hanover was located in South Hanover. An 1857 Hanover map shows that E.Y Perry also had a general store built about that time. Later, William Sherman, Thomas Drew, Ernest Bates, Ella May Bates, Herbert Jefferson and others ran the store and post office, located at the present location of Myette's Store at the corner of Broadway and Cross Street.

As long as Perry was living, he gave instructions that two articles never be sold in his store—"rum and ladies' corsets." Charles Gleason related the following story about Perry:

> *When Mr. Perry had finished building his railroad, he put I.G. Stetson, who lived on the site of 1119 Broadway, near the station, in charge of the first train as conductor. His son, Fred Stetson, was the station agent. Nearby, in a space later taken up by a second store, were located two apple*

trees. Mrs. Stetson, on her way home from Perry's Store, stopped under one of these trees and picked up an apron full of apples to take home and doubtless made a wonderful apple pie. However, a neighbor lady saw her fill her apron with apples and reported to Mr. Perry. A general row ensued, and I.G. Stetson and his son, Fred, lost their jobs over the incident. Mr. Stetson, however, somehow got hold of that piece of land, cut down the apple trees and put up a store next to the Perry store. Now Mr. Perry had competition, and he did not like it one bit. Mr. Stetson did much better financially than he had done as a conductor. Fred, his son, began a stable business, living upstairs over the store part of the time, and later in his father's home.

William "Reel" Whiting, an interesting gentleman and sometime poet, took over the store in the late 1800s until 1916. In his poem about South Hanover, "Reel" Whiting tells us that in the village, John Handy shoed horses and Manuel had a barbershop, that Irving (Kingman) ran a livery stable and Tom Tindale raised cranberries. Charlie Gleason said the building was called Harmony Hall, and many band concerts and dances were held there. It was moved sometime in the 1930s.

Another business located right beside the tracks near Iron Mine Brook was a factory, Goodrich Shoe Company, which E.Y. Perry built to entice Mr. Goodrich to move his shoe factory from North Hanover to South Hanover, where the railroad could serve his business well. Later, Goodrich moved his business to Brockton, and the building was used by the Cochran Shoe Company, the Shanley Shoe Company and the Clapp Rubber Company. Later, chickens were raised in the run-down building before it was taken down.

Another business in South Hanover was the Bonney Ink Factory, located on the north side of Broadway just east of Goodrich's. William Bonney, known as "Ink Bonney," did a good deal of experimenting before he had a product he dared to offer in competition with other established companies, but eventually he had them coming to him. He had a two-story shop where he had mixing vats, dyes, pots and other paraphernalia he used in the manufacture of his special ink for about forty years, from just after the Civil War into the early 1900s. An accident nearly blinded him, and his daughter, Cora, tried hard to carry on, but she finally sold out the dyes and formulas to the Carter Ink Company.

The village schoolhouse was located on Broadway near the intersection with Cross Street, and the children walked to school to learn their reading,

writing and arithmetic. Along Broadway and Cross Street in South Hanover are located many of the old houses of village residents who worked in the mills and stores, farmed the land, gathered at the post office for the news and a chat and helped their neighbors. The spirit of community is still present there today.

SOUTH HANOVER BUSINESS DISTRICT, 1902

On the Indian Head River between Pine Hill and Rocky Run Brook in South Hanover, a dam was built and a bridge constructed over the river into Hanson, and the water power provided an excellent mill site for several businesses and factories to follow. The last of the big factories located here was the Goodrich Shoe Company.

Let us go back to the beginning of the development of this site. In 1720, the town granted two acres of land on the Indian Head River at this site to Joseph Barstow and Benjamin Stetson "for the accommodation of a forge and finery." The forge was known as Barstow's Forge. Captain Barstow also held interest in a gristmill and a sloop, and at his death in 1728, his estate was valued at $30,000, quite a sum in those days. His youngest son, Joshua, only eight years old, inherited the forge. He soon learned the business and continued it until his death by drowning in 1763 at age forty-four, leaving the forge to his son, Joshua, then fourteen. He continued until 1795, when he moved to Exeter, New Hampshire.

During the Revolution, cannon balls were said to have been made here. Joshua Barstow melted the iron at an ordinary forge fire and molded them in the bottom of his forge. Robert Salmond became the next principal owner in 1795, until his death in 1829. He was engaged in the building of anchors, among other things. About 1825, Salmond and Thomas Hobart of Abington, who had become part owner, had a contract from the U.S. government for the manufacture of anchors for the navy. John Sylvester joined the firm in 1825, and by 1829, about one hundred tons of bar iron and one hundred tons of anchors had been made, and twelve to fourteen tack machines were run—several built yearly. By 1830, locomotive cranks were being made here.

Under the leadership of Sylvester, the Hanover Forge Company continued until 1853, when it was sold to Mr. Phillips, Mr. Perry and Mr. Stetson. Of course, Perry's railroad was able to bring in the raw material and ship out

the tacks and other products. In 1874, Perry withdrew, and the tack factory became known as E. Phillips and Sons, under which name it continued until it was purchased (I'm not sure when) by the United Shoe Machinery Company, which had for years been buying up tack factories all over the East and closing them so that they might have a monopoly in the business. It was torn down before 1945.

Ezra Phillips was a man of fine reputation. Half-brother of Lot Phillips, who ran the Box Company in West Hanover, Ezra was born in 1810 and died in 1882. His two sons continued in the business, which provided well for the Phillips family for several generations. In 1889, it employed about fifty men from Hanover, Hanson and the surrounding area. They worked seventy-one tack and nail machines, a rolling mill and a machine shop and had a sixty-horse-power engine. They cut that year about 750 tons of nails and tacks and rolled 250 tons of zinc and lead. Perry wrote of his business partner, Ezra Phillips, "I consider him one of the grandest and best men I ever knew....It was simply a pleasure to do business in connection with such a man."

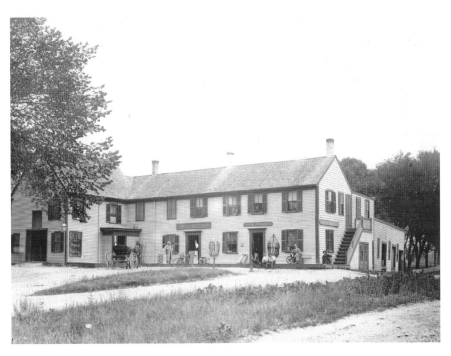

Hanover residents know it today as Myette's Country Store, but the building once served as the center of the E.Y. Perry empire.

The E. Phillips and Sons nail and tack factory employed about fifty men from the surrounding community.

There were problems being located on the river. Several bad storms broke down the dams at various times. Charles E. Turner, a trader of sorts in South Hanover, whose diary we have courtesy of Elsie Nelson, wrote on February 18, 1867, "Great Excitement! Water Water Water! Great Freshet! Cushing's Dam gave away The bridge down by Perry's Factory! Blueing Shop went down stream. Greatest time ever known!" Later, Turner reported working on the road and repairing the dam. Again, in February 1886, according to chronicler L. Vernon Briggs, "an uncommonly heavy fall of rain caused a flood along this valley....[A]t E. Phillips & Sons tack-factory at South Hanover the dams were nearly destroyed." And there were others. Many remember the hurricane of 1938 and storms in 1954 and 1955 that took out more of the dams along the Indian Head. Now, it is hard to believe South Hanover was such a busy village.

The general store was the central gathering place in each of the villages of Hanover at the beginning of the twentieth century. In South Hanover, the general store at that time was owned by E.Y. Perry and included the post office and the Thomas Drew Boot & Shoe Store. This complex is now part of Myette's Country Store on the Corner of Broadway and Cross Street. The post office was established in South Hanover in 1864 and was located usually in the store of the village. Isaac G. Stetson was appointed

the first postmaster and remained in office until 1897, when Thomas Drew took over. Mrs. Ernest Bates was postmistress until 1944.

The 1857 map of Hanover shows that a store owned by E.Y. Perry was located on the corner of Broadway and Cross Street. Perry had many business interests in town, so I'm not so sure that he, himself, was behind the counter that often, but he did set policy; he decreed that two articles never be sold in his store: "rum and ladies' corsets." Perry and his wife lived over the South Hanover store for many years. They had one daughter who died in early infancy. They celebrated their fiftieth wedding anniversary in 1884.

Perry was an unusual man. He was certainly an entrepreneur. His business interests in town included, at various times, the general store at South Hanover; the tack works at Project Dale; John Sylvester's Hanover Forge Company, which became the tack works at South Hanover and later Ezra Phillips and Sons; interests in Lot Phillips Box Factory; the mill at West Hanover and a grain business that became Culver, Phillips, & Co. He also had interests in mills in Waldoboro, Maine. Never idle, he was engaged in the buying and selling of real estate, lumber and wood. He was president of the Hanover Branch Railroad, and it was through his leadership that the railroad was completed and running at a profit for many years.

He had a competitive nature and drove a hard bargain, but there was a very humanitarian side of this complex man. He was a justice of the peace for twenty years, a member of the state legislature in 1897 and identified with the antislavery movement, belonging to the Garrisonian organization from its beginning to the emancipation of the slaves. He advocated temperance in the strictest sense. In 1880, he stopped taking interest on any of his liens and collected no interest on many mortgages.

Edward Y. Perry died in 1899 at age eighty-six. A large part of his property was left for the benefit of poorer people and a trust fund for worthy young people of Hanover, Hanson and Pembroke who needed help in acquiring a college education. This fund still continues today, and scholarships in his name are still awarded. And so, the name of E.Y. Perry is not forgotten in the annals of our history. He started as an orphan, raised by elderly grandparents, and through a sharp mind and hard work, he accumulated a fortune. He was a country merchant, a businessman, a bargainer and a humanitarian whose influence is still felt today.

THE GOOD LIFE IN HANOVER

LEISURE TIME ACTIVITIES

What did people in Hanover do at the beginning of the twentieth century in their leisure time in the summer?

For the working farmer and his family, there was not much leisure time, but even they went to the Memorial Day exercises and lunch at the Center. All boys shot off a few firecrackers and turned a few tricks on Fourth of July, which was capped off by a family picnic. Labor Day ended the summer with a family gathering and picnic. Women could wear white only between Memorial Day and Labor Day. Croquet was introduced into the United States in the 1870s, first to the wealthier families, but later, many local families set up croquet fields on their side lawns. It was the first popular outdoor game played by both sexes. The equipment was affordable, and all could enjoy the rather mild sport. A lady, however, was supposed to swing her mallet with an outside stroke rather than from between her legs.

Croquet began to decline in popularity when tennis became more popular. Young people wanted a more energetic outdoor game where they could flirt with the opposite sex without alarming their parents. The Phillips on Broadway had the first and—for a long time—the only tennis court in Hanover. Morrill Phillips had the court constructed in the late 1890s, and it was a great hit with his family and neighboring young people. The grass court was first laid out east to west but was later changed to a clay court going from north to south.

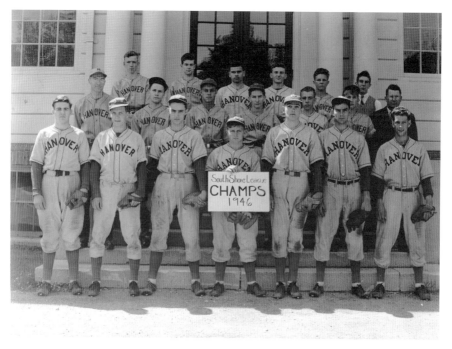

A side effect of the Industrial Revolution was the rise of leisure time, with the formation of groups of people who shared similar interests and the time to pursue them. Hence, the rise of sports. Here, the 1946 South Shore League Champs pose in their baseball uniforms.

I interviewed Betty Hall Rattle, a niece of Aunt Fan Phillips. Betty Rattle remembered playing on the courts with her brothers, sisters and neighbors, and what great fun they had. They would play from early in the season until fall and until it got too dark to see the ball.

Betty remembered that while waiting for a turn to play, her brother Jim, who was great fun, would organize a game called "Hail-ye-over." Two teams were formed, and they would each take a side of the carriage shed. The first team would throw a tennis ball over the roof of the carriage shed and call "Hail-ye-over." The other then would try to catch the ball, and if they did, the one who caught it would run around and try to tag as many of the other team as he or she could. If the ball was dropped, they threw it back and yelled, "Hail-ye over."

During the hot summer months, some Hanover families built or rented a beach house over in Scituate or Marshfield. The Simmons family would spend a week in Scituate, sitting on the piazza, swimming and sailing. Of course, the bathing costumes (as they were called) would seem ridiculous to

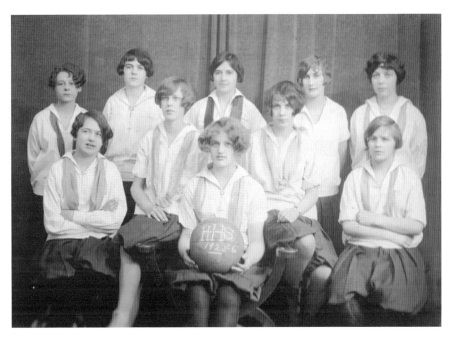

Invented in 1892 in Springfield, basketball quickly became a sport for both boys and girls.

us today. The suits of both men and women were of itchy wool, and you were lucky if yours didn't have moth holes. Women wore bathing shoes and stockings—no leg flesh showing, please.

Horseshoes was a popular sport with the men, particularly the older generation. Bicycling was also a popular activity. In the Simmons diaries of 1893, John Simmons was said to cut quite a figure on a bicycle as he rode around Assinippi. Young May Simmons belonged to a bicycle club that met at the church and cycled as far as Plymouth. Bloomers became the costume for cycling introduced by Amelia Jenks Bloomer, who gave her name to the split skirt designed for bicycle riding and adapted for other activities as well. The phrase "the new woman" began to take on significance with these published lines in 1898: "Then shout hurrah for the woman new/With her rights and her votes and her bloomers, too!/Evolved through bikes and chewing gum/She's come!"

Golf, although a rich man's sport, allowed men and women recreational companionship, which also led eventually to more casual clothing for women. I don't think too many Hanover men or women played golf, though. The popularity of baseball grew after the Civil War and was reflected in the small

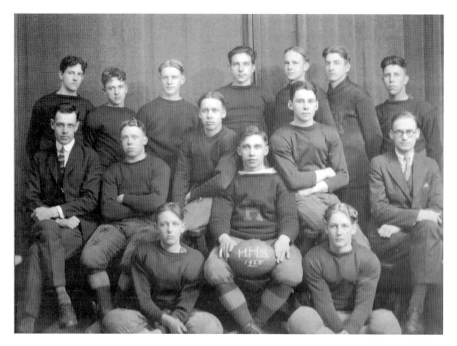

Football was once played by men in baggy pants and horsehair shirts, as there could be no tackling below the waist.

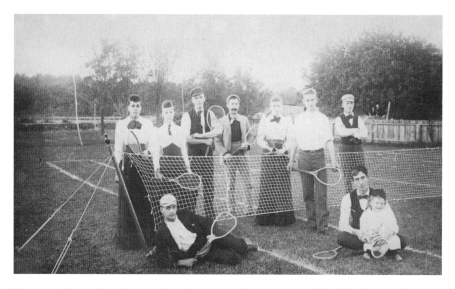

Lawn tennis proved to be more than just a sport. It was a way to flirt with the opposite sex without raising eyebrows.

towns like Hanover. Several of the villages formed teams and played each other. The North Hanover boys were fortunate to have the Brooks brothers playing for them, as they were great athletes. However, they were Baptists, and when some games were played on Sunday, the Brooks boys didn't play. Although there was neither radio, movies nor TV, there was always plenty to do. Families and young people just got together and had fun. Life was simpler then.

CELEBRATIONS IN HANOVER

Long ago, the Hanover Fire Department sponsored the Columbus Day parade. Harold Arnold, whom some old timers may remember, related this story of the float titled "A Little Child Shall Lead Them":

> *The theme was based on an actual happening. The fire bell was on top of Louis Stone's barn, and the fire wagon kept inside. One day a fire call came in and no men were nearby. Two little girls, Dorothy Studley, and the other was one of the Phillip's girls, as I remember…rang in the alarm, pulling the bell rope. My grandfather (Alpheus Packard) made the lettering and built a bell in the cupola, using dwarf geraniums on a wire fame. One side said "Ringing in the Fire Alarm." The other side read "A Little Child Shall Lead Them."*

Celebrations were more frequent in the old days. Memorial Day was an all day long and community event. In 1877, there was a celebration for the 150th anniversary of the founding of the town, and the historical society has a framed broadside telling of a picnic at the grove. The society has the receipts for the expenses of this celebration. Apparently, dippers were given out as mementos, as we have a receipt for four hundred dippers at five cents apiece. Has anyone ever seen one of these? In 1903, there was a special "Old Home Week," which published a wonderful booklet of old pictures, history, poetry by local poets and genealogy. A field day was held and probably a dinner and other events. I suspect there were other "Old Home" weeks of which we have no record.

Then there was the 200th anniversary celebration in 1927. It lasted a week, beginning on Sunday, June 12, with observances in the churches; exercises and orations and music at the town hall on the fourteenth; a Children's Day

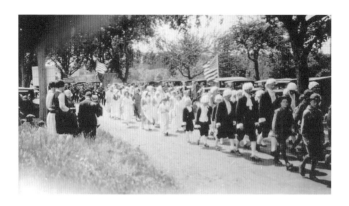

Hanover residents paraded a lot in the old days. In 1927, the town celebrated its bicentennial, followed in 1930 by the Massachusetts tercentennial.

on Friday with entertainment, games and prizes; and supper at the town hall. On Saturday, the week concluded with a Firemen's Field Day, a parade, a band concert and fireworks. A float from that parade depicted a boat (Hanover's shipbuilding industry), the anchor forged for the USS *Constitution* in Hanover and the iron plough invented by David Prouty of Hanover. I have heard this float did double duty and appeared in the Massachusetts Tercentenary parade in 1930, as well as local citizen George Miller, who dressed as George Washington.

There was a celebration at the end of World War I of which I have no details. In 1946, a celebration was held to honor the veterans of World War II. Charlie Gleason, in his scrapbook, recorded a parade with floats, flags and festivities. Speeches were made at the soldiers' memorial flagpole in front of the Sylvester School. Hanover honored its veterans.

Many of us remember the bicentennial celebration in 1976. Chaired by our good friend, John Libertine, a wonderful Patriot's Ball was held at the Hanover Mall. A chicken barbecue and bonfire followed games at Sylvester Field. The new Hanover Militia demonstrated a mock encounter with the British at the Four Corners. This was the year the Lions planted and lighted the spruce tree at the library for Christmas. The following year, 1977, was the 250th anniversary of the town, which even surpassed the previous year. Another ball and supper were held at the mall. A special anniversary quilt was made by ladies in the town, and it now hangs in the large hearing room at the town hall. The most exciting event was a huge parade, the likes of which the town had never seen before: bands, military units, floats decorated by almost every club and organization in town, fire engines, mounted police, Clydesdale horses and over twenty antique autos. Over 1,700 people took part, and the parade was viewed by thousands along the roadside for the two hours it took from start to finish. Other events included

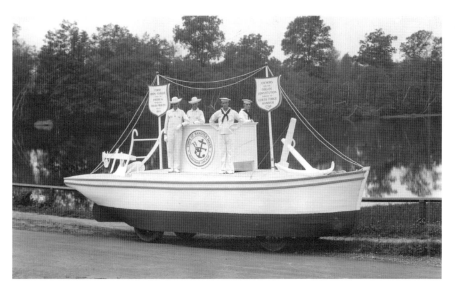

Two farmers and two sailors ride this Town of Hanover parade float commemorating the development of the Prouty plough and the forging of the anchors of the USS *Constitution* in Hanover.

a road race, field events, a barbecue, an ecumenical pageant and a bonfire. The addition to the town hall and new police station were dedicated and a time capsule buried. It was a grand time.

Hanover has been proud of its town, its people and its history and enjoys a good celebration. No big city prices, no traffic, just a great time with your fellow townspeople.

MEMORIAL DAY

Many people of eight decades or more remember when Memorial Day was always on May 30, and families decorated the graves of their families and loved ones. Many families today, even though Memorial Day, the last Monday of May, does not often fall on the thirtieth, still visit the cemetery and place geraniums on the graves of our parents, grandparents and loved ones. It is a day to remember.

The tradition of "Decoration Day," as it was commonly called, began with a group of southern women who put flowers on the graves of the northern soldiers who were buried there, as well as remembering their own

fallen heroes. When I was in grammar school, I memorized "In Flanders field the poppies grow/Besides the crosses row on row," and I was chosen one year to present the flowers to the Civil War veterans who attended our school for our ceremonies. They seemed very old—in fact, they were—and one by one, they died off until there were none left who had taken part in the War Between the States. Charlie Gleason recounted that the day before Memorial Day, someone would visit every home and collect beans, potatoes, bread, pies, cakes and all the fixings, and then on Memorial Day, everyone was invited to a free dinner at the town hall. After a good dinner came speeches, singing and children's recitations. All this took all day. People came in their wagons, put the horses in the sheds down back (of the town hall—now part of the Boy's Club) and visited.

REMEMBERING ARMISTICE DAY

Each November 11, the country celebrates Veterans Day as a national holiday to honor veterans of past wars. The roots of this day go back to 1918, when, on the eleventh hour of the eleventh day of the eleventh month, the world rejoiced and celebrated the end of World War I, and the armistice was signed in a small French town. The "war to end all wars" was over, and the day was designated as Armistice Day.

After four long years of a bitter war, the boys came home. In Hanover, the effects weren't felt so deeply until 1917, when seventy-nine boys enlisted, and in 1918, when twenty-six more went to serve their country, according to the town reports. Of those who left their hometown, three died: Private First Class Charles E. Cummings, killed in France; Private Leon W. Josselyn, killed in France; and Corporal James J. Levings, who died in the hospital.

While the soldiers were fighting in the trenches, those at home wanted to do their part for the war effort. The people in Hanover showed great sympathy for the British and French allies as well as for the local boys in the service. They bought Liberty bonds and formed a special branch of the National Special Aid Society for American Preparedness, which met regularly to make surgical dressings, knit and sew hospital supplies for the Red Cross, the Army and Navy League and the French wounded. They also filled comfort bags and Christmas boxes for the Public Safety Committee. The Women's Relief Corps, the Fire Department, Camp Fire Girls, the Summer Club, the Riverside Associates, the American Ambulance Hospital

Workers and the E.Y Perry estate provided the funds for this work. Also, fundraising entertainments were held by other various groups.

People volunteered to help out in any way they could. Many went to work at the National Fireworks, which, in 1914, began making ship signals, flares and torpedoes for the Allies. Then, in 1917, the whole Fireworks complex was retooled and joined the war effort in full. This company was famous worldwide for developing a method of making tracer bullets and worked extended hours to fulfill a huge government contract. Others helped boost the spirits of the boys and wrote letters telling of the news at home.

Catharine Phillips served for a short time as a manager for a house in Provincetown that was a haven for off-duty military personnel and their families, sort of a USO. One of the ways most families helped with the war effort was to conserve critical food supplies so that they could be sent to those fighting to make the world "Safe for Democracy." Each family was given a ration book. A U.S. Food Administration pamphlet gave these suggestions as to "What You Can Do to Help Win the War." The problem was stated "to feed the Allies and our own soldiers abroad by sending them as much food as we can, especially wheat, beef, pork, butter and sugar." Suggestion: "Have Two Wheatless Days, (Monday and Wednesday), and One Wheatless Meal every day. Have One Meatless Day (Tuesday) and One Meatless Meal every day. Have Two Porkless Days (Tuesday and Saturday) Make every day a Fat-Saving Day, Make every day a Sugar-Saving Day, Use Fruits, Vegetable and Potatoes abundantly, Use Milk wisely." Another government publication said, "They have gone into the trenches; will you go into the Kitchen?" and then proceeded to give nutritional information and suggested recipes with meat substitutes and nitrogenous foods. There are several recipes using dried ground peanuts. Here is one for "Liberty Escallop": "Use the peanut foundation in alternate layers with war-bread crumbs mixed with minced celery tops, or outside pieces; dampen with any vegetable stock, tomato juice, or failing these, use water. Cover the top with crumbs and brown in the oven." Does this sound yummy?

There are other equally different recipes. Among them are directions for Liberty Casserole, Liberty Shepherd's Pie, Liberty Curry and Liberty Hash. Herbert Hoover, then U.S. Food Administrator, is quoted in one: "Our wheat situation is today the most serious situation in the food supply of the whole wide world." Recommended was to "Use Potatoes to save wheat," as well as recipes for potato bread, chocolate potato cake, potato cookies and so on. I don't think you would want these.

To keep their spirits up, songs like "Keep the Home Fires Burning," "Over There" and "Somewhere a Voice is Calling" were sung as the hometown people gathered and remembered those fighting for liberty. And so all rejoiced and gave thanks for the sacrifices when the armistice was signed on November 11, 1918. Although celebrated yearly on that date, Armistice Day was not made a legal holiday until 1938, when it was officially voted by Congress.

After the Second World War, Armistice Day continued to be observed on November 11. In 1953, the little town of Emporia, Kansas, called the holiday "Veterans Day." In recognition of the veterans of both wars, soon a bill was introduced and passed by Congress to rename the holiday Veterans Day. Veterans of all wars are now included in the remembrances on Veterans Day, November 11. Let us all give thanks and remember the sacrifices of those who served and those families who lost loved ones. Let our children not take for granted the freedom we enjoy.

Epilogue

SIGNS OF SPRING IN HANOVER

I'm not sure what poet said, "If winter comes, can spring be far behind," but I take great solace in that observation. This year, the groundhog told us that it was going to be an early spring. I hope he was right. I haven't seen my groundhog yet, but I hope he has moved and is welcoming in spring elsewhere as I write.

In Hanover in the middle of February, you may have noticed two great splashes of yellow along the west wall of the carriage shed at the Stetson House. "What could be blooming so early?" you ask. "Surely not forsythia." Witch hazel is the answer; it is one of the earliest signs of spring in New England. In fact, it blooms as early as December, but I first noticed it at the end of January. A lotion or potion made from the bark and flowers can be used as an astringent to relieve itching. I prefer to merely consider it an early sign of spring.

The Hanover Garden Club planted the attractive area between the library and to the rear of the Stetson House and barn with native shrubs and wildflowers. They welcome you to discover the bloom of the witch hazel and other treats along the paths as the season progresses. If you haven't gathered your pussy willows yet, you'd better hurry. It's almost too late. Put them in water, and they'll grow roots; plant them in a damp place, and you'll have your own pussy willow bush in a few years. My snow drops have been blooming since January. Their little white bells open up on sunny days, then curl up when winter asserts itself. But they are persistent and keep blooming through March.

The sap is rising, and the buds begin to swell. The weeping willow takes on a chartreuse tone, and the swamp maples show pink. The skunk cabbage begins to break through the mud. The snow crocus, a well-known harbinger of spring, will bloom through spring snows and promises sunny days ahead. Snow crocuses have been blooming by the back walk at the Stetson House for several weeks. For most Hanover people, the early crocus at the old post office announced to the town, "Spring is here!" Do you think they still bloom even though they no longer have spectators? I think they do. I checked, and they were blooming their little hearts out. They love that south brick wall, which holds the heat and draws them out of the winter depths like magic.

The brick wall on the south side of the Sylvester School has a similar exposure. In 1983, my fifth grade class planted crocus and daffodils in their own "secret garden," and I introduced my classes to the magic of spring. I think that garden still welcomes spring to children. Following the bloom of the crocus is the dwarf iris, *chionodoxas* and *squills*. Finally, as April approaches, my favorite, daffodils, raise their golden trumpets and herald the true spring. The daffodils will bloom at the schools, along the roadway and in yards all over Hanover. Some are the result of the "Trash for Bulbs Trade" sponsored by the Hanover Garden Club in the fall, when individuals, groups and business people cleaned up the roadsides of litter and traded the collected trash for daffodil bulbs, and we all are rewarded with their bloom

Students graduating from Hanover High at the Sylvester School annually posed for class photos in front of the Civil War monument just down the street.

in the spring. The spring bulbs are not only beautiful but also rugged, and we cannot help but admire their optimism.

Of course, we mustn't forget the forsythia. Everyone should have a bush from which to pick early to force their golden blossoms into early bloom in the house, and later to enjoy their wonderful mid-April flowering. In Hanover, one of the prettiest shows of forsythia is on the corner of Oakland Avenue and Broadway. Late spring brings tulips and the flowering shrubs and trees. Along Route 139 in 1976, the bicentennial year, some businesses and individuals planted flowering cherry trees. Quite a few survived. Watch for them.

The lengthening of the daylight hours signals to some birds to move farther north. The winter residents begin their mating songs. Some robins have remained for the winter and get a jumpstart on spring. Others have just arrived and think they have discovered spring. The cry of the red-winged blackbird is heard near the wetlands. The woodpecker taps out his signal to all that this is his territory—females welcome, males should move on.

To some people, one sure sign of spring is the first warm evening when the noise of the spring peepers is heard from the swamps. Overnight, it seems the grass turns green and the dandelions bloom. The alewives swim up the brooks to spawn in the fresh water. The shad follow a few weeks later and draw fishermen from all over the state to the Indian Head River. Other fish become active, and fishermen dot the edges of the streams to try their luck. Optimism runs high. Baseball players young and old feel the desire to get out and hit a few. Spring practice begins. Of course, the return of the Red Sox to Fenway is a sure sign of spring for many. Hope springs eternal. The March winds may blow; the April showers will bring May flowers. Life is pushing out of its winter sheath, and all the world welcomes spring.

Life renews itself, and the cycle begins again.

ABOUT THE AUTHOR

Barbara Barker wrote forty thousand words about her hometown, Hanover, Massachusetts, where she lived from 1964 to 2016. She was an elementary school teacher for over forty years, a caring, passionate teacher of math and history who enriched the lives of hundreds of students. She was a natural leader who took great satisfaction in giving back to her town and was named Hanover Town Historian for her knowledge and dedication. She was the second recipient of the Spirit of Hanover award, coauthored two books on the history of the town, served as president of the Friends of the Stetson House in Hanover and was a board member of the Hanover Historical Society. As well as writing and directing original plays, she took students on guided bus tours that brought the history of their town to life and was the heart and soul of the Stetson House annual Christmas tour.

Hope springs eternal in Hanover, with the rejuvenating seasonal cycle reminding us that what has gone before will come again.

ABOUT THE HANOVER HISTORICAL SOCIETY

Since 1927, the Hanover Historical Society has promoted a better understanding of Hanover's unique heritage through education and preservation. Headquartered in the historic Stetson House at Hanover Center, the society provides innovative educational programs for all ages, partners with collegial historical agencies in surrounding communities and along the North River and provides a stable environment for the conservation of its vast collection of books, textiles and objects. Membership opportunities, as well as the doors of the Stetson House, are open to anyone interested in Hanover history.

Visit us at
www.historypress.com